COASTAL GARDEN
PLANTS

FLORIDA TO VIRGINIA

ROY HEIZER
PHOTOGRAPHY BY
NANCY HEIZER

Schiffer Publishing Ltd

4880 Lower Valley Road • Atglen, PA 19310

Other Schiffer Books by the Author:
Savannah's Garden Plants, ISBN: 978-0-7643-3265-4, $9.99
Atlanta's Garden Plants, ISBN: 978-0-7643-3810-6, $14.99
Savannah's Historic Churches, ISBN: 978-0-7543-3864-9, $16.99

Copyright © 2012 by Roy and Nancy Heizer
Library of Congress Control Number: 2012948103

Designed by Justin Watkinson Type set in Minion Pro/Zurich BT

ISBN: 978-0-7643-4181-6 Printed in China

Published by Schiffer Publishing, Ltd.
4880 Lower Valley Road
Atglen, PA 19310
Phone: (610) 593-1777; Fax: (610) 593-2002
E-mail: Info@schifferbooks.com

For the largest selection of fine reference books on this and related subjects, please visit our website at **www.schifferbooks.com**. You may also write for a free catalog.

This book may be purchased from the publisher.
Please try your bookstore first.

We are always looking for people to write books on new and related subjects. If you have an idea for a book, please contact us at
proposals@schifferbooks.com

Schiffer Books are available at special discounts for bulk purchases for sales promotions or premiums. Special editions, including personalized covers, corporate imprints, and excerpts can be created in large quantities for special needs. For more information contact the publisher.

In Europe, Schiffer books are distributed by
Bushwood Books
6 Marksbury Ave.
Kew Gardens
Surrey TW9 4JF England
Phone: 44 (0) 20 8392 8585; Fax: 44 (0) 20 8392 9876
E-mail: info@bushwoodbooks.co.uk
Website: www.bushwoodbooks.co.uk

CONTENTS

ACKNOWLEDGMENTS

I'd like to thank my friends and family for their support of this project, and everyone at Schiffer Publishing. I especially thank the following institutions:

Lewis Ginter Botanical Garden in Richmond, VA.
Norfolk Botanical Garden in Norfolk, VA.
The City of Wilmington, NC
Brookgreen Gardens in Murrells Inlet, SC
The City of Charleston, SC
The Cummer Museum in Jacksonville, FL
Leu Gardens in Orlando, FL
Fairchild Tropical Botanic Gardens in Miami, FL
The City of Tallahassee, FL

and the people of:

Virginia Beach, VA
Elizabeth City, NC
Kitty Hawk, NC
New Bern, NC
Savannah and Tybee Island, GA
Brunswick, GA
Jacksonville and St. Augustine, FL
Clearwater, FL
Tampa, FL
Pensacola, FL

INTRODUCTION

The southern coastal region has an abundance of flowers, plants and trees waiting to be explored by gardeners from all over the world. With this book as your guide, explore the history, folklore and ethnobotany of America's *Coastal Garden Plants; Florida to Virginia*. From tropical Florida to northern Virginia, gardeners will find fun facts and growing tips covering a wide range of culinary, ornamental and garden plants.

Discover which tree was featured on the cover of a classic book from the 1950's. Find out how a palm tree and our highway system are related and which grass is planted to stop beach erosion. Appreciate which plants are associated with ancient cultures and held sacred in religious services. What do a bee keeper in Arkansas and a coastal plant have in common?

The plants listed in this book are arranged in alphabetical order by botanical name with a common name cross reference guide for easy use. Over 220 full color digital photographs, taken in their natural settings, make plant identification easy and accurate.

Coastal Garden Plants; Florida to Virginia shares fun facts and amazing tales about the flowers, plants and trees along the coast of Florida, Georgia, South Carolina, North Carolina and Virginia. Dig in and see America's coastal plants from a whole new perspective!

THE
PLANTS

Acer Palmatum

Japanese Red Maple

Year Round

Acer - Maymont

Bloodgood Japanese Red Maple at Maymont, in Richmond, Virginia.

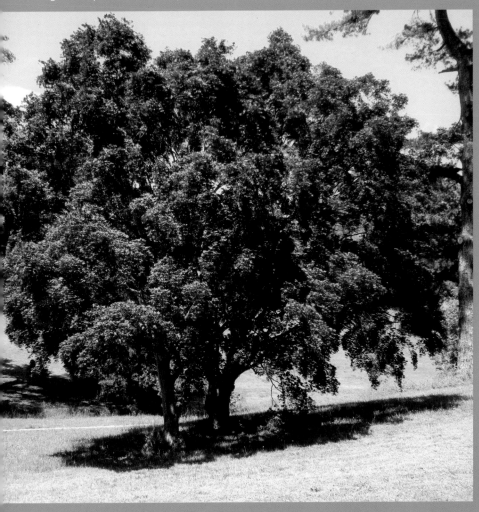

Japanese Red Maples are dwarf hybrids developed hundreds of years ago in Japan. Standard Maples were dwarfed through careful seed selection for use in the art of Bonsai. Several Japanese Red Maple varieties exist with leaf color ranging from rich burgundy to bright lime green. All Japanese Red Maples display stunning fall color and do best in milder climates such as Virginia and North Carolina.

Agave Americana Var. Marginata

Variegated Agave or Century Plant

Evergreen, rare flowering

Agave

This 5'x6' variegated specimen is a hybrid.

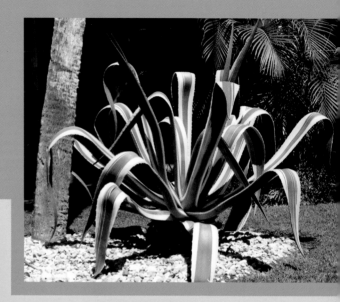

While most gardeners are aware of the regular grey/green Agave, the Variegated Agave is gaining in popularity. The green-to-yellow striping adds contrast to the coastal landscape. The Variegated Agave can be planted right at the beach or a bit further inland with the same growing conditions as the regular Agave.

This Mexico native is smaller and has more curvature of the leaves than the regular Agave. While still displaying the same sharp barbs along the leaf margin, the Variegated Agave lends itself to a wider range of landscape possibilities than its larger cousin. The Variegated Agave is sometimes called the Century Plant for its rare and sparse flowering schedule. All members of the *Agave* family will produce pups, or offsets, around the base of the plant. These pups can be pulled or dug up and replanted to start a new grouping.

Historically, the *Agave* family has served Mexicans as a food source. Four parts of the *Agave* are edible: the leaf, the flowers, the stalks and the sap. The sap is boiled down into a thick sweet liquid and called *Aguamiel* (Honey water) in Spanish. The *Agave* is also the source plant for Tequila, a popular alcoholic drink that originated in Mexico.

Ajuga Reptans

Bugleweed

Spring to Summer

Ajuga

Ajuga attracts bumblebees and fairies to the coastal garden.

Ajuga is a reliable flowering groundcover that forms thick low mats in coastal regions. The textured leaves of the Ajuga range in color from glossy green to burgundy. In the early spring, an individual plant will develop a four inch flower spike. Each one of these spikes holds several small bell shaped flowers. Ajuga flowers are usually light purple, but can blend into a blue palette. In the north, Ajuga can be grown in full sun, whereas in the south it does better in a shady area.

In ancient English folklore, the Ajuga is said to be a ground cover because it possess a happy spirit that wants to spread joy around the world. The flowers that pop up on the *Ajuga* are looking for gardeners to make happy.

In folk medicine, the Ajuga is noted for its ability to stop bleeding.

Shrub Allamanda

Spring to Summer

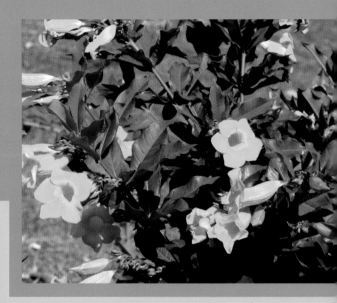

Allamanda Nerifolia

Allamanda is best suited for gardening zones 8, 9 & 10.

English Country and Contra dancers know a calling term "Allemande left" or "right". Allemande comes to the English language through the French, and means Germany. This dance term is where the Shrub Allamanda gets its name, reflecting the twining stems and the turning of the flower toward the sun.

Gardeners of yesteryear used to say "When the Allamanda flowers, leave the porch light on because company is coming."

Shrub Allamanda is a warm climate, flowering plant that grows from southern Florida to Charleston, South Carolina. A member of the Dogbane family, Shrub Allamanda looks similar to its other family members with bold colors on both the flowers and leaves. The bright yellow flower of the Shrub Allamanda brings a light and colorful display to the full-sun border.

Allium Christophii

Star of Persia or Ornamental Onion

Spring to Summer

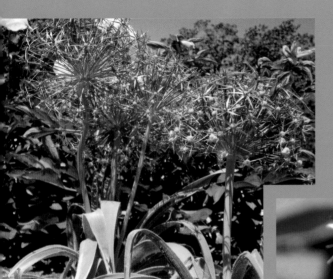

Allium Christophii

This spring flowering Onion attracts butterflies and moths in the tidewater region.

At last! A deer-resistant garden plant! Star of Persia is the perfect ornamental flower for areas plagued by grazing deer. The strong onion scent repels deer while attracting bees, butterflies and attention in the Virginia and North Carolina garden. A bulb perennial, Star of Persia needs to be planted in October or November and lightly mulched. In the spring, a twelve-inch-tall, softball- sized flower cluster will emerge above soft, hairy, lily-like leaves.

The botanical name *Christophii* was given in honor of Henri Christophe, the first president and later king of Haiti. He was also an important figure in the Haitian revolution that helped Haiti gain independence from France in 1804. Christophe, as president and king, encouraged his countrymen to plant many culinary and cultural crops, including Alliums. Christophe would have been familiar with the Voodoo tradition and the use of Alliums in Voodoo practice. In Voodoo, the Onion represented mystery or the unknown. The layers were said to be obfuscation of the truth. If the subject of Voodoo practice was unknown, an Onion was used to represent the mysterious person or thing.

Amsonia Hubrectii
Blue Star

Spring to Summer

Amsonia Hubrectii

An Arkansas native
visits the beach.

Amsonia Hubrectii is native to north central Arkansas, but grows with ease along mid-Atlantic coastal regions. A wildflower, Blue Star is a member of the widely known Dogbane family. With powdery blue star shaped flowers and thin wispy leaves, the Blue Star is a clump forming perennial. Blue Star develops wonderful fall color in October, with hues of gold and yellow lasting for several weeks.

Since it's nectar attracts bees, Blue Star has become a favorite garden plant among bee keepers, both in Arkansas and in the Richmond to Virginia beach areas. Butterflies and moths can also be seen visiting Blue Star groupings.

Anemone
Daughter of the Wind

Spring to Summer, varies by species

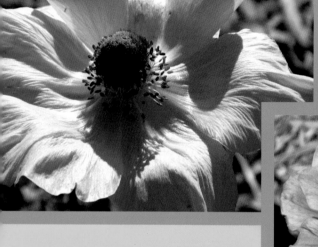

Anemone

Anemone is an old-fashioned garden favorite.

Daughter of the Wind grows as an annual in Virginia & North Carolina, but grows as a perennial in South Carolina & Georgia.

The gardener who wants year-round color need look no further that the Anemone. A member of the Ranunculus family, Anemones count Aconitums, Buttercups, Clematis, Delphiniums and Pasque flowers among its closest relatives. There are many varieties of Anemone, with species that open in all four seasons. The spectrum of the Anemone ranges from pure white to deep red. The flowers of the Anemone sit on straight stems facing upward toward the sun. They are often planted in mass, giving an overall effect of a wildflower collection. The lace-like leaves tell of the Anemone's relation to the Larkspur.

Anemone is one of a few garden plants that has no petals. What most gardeners think of as a petal set is actually a colored sepal. A sepal is the covering that protects a petal set before it blossoms. On many flowers viewed from underneath, the sepal is the green, leaf-like part up against the petals. Most Anemones are twelve to sixteen inches tall and need to be grown in full sun with minimal water.

The common name, Daughter of the Wind, is a rough translation of the word *Anemone*, coming from the original Greek.

Anomatheca Laxa

Shines at Night

Spring

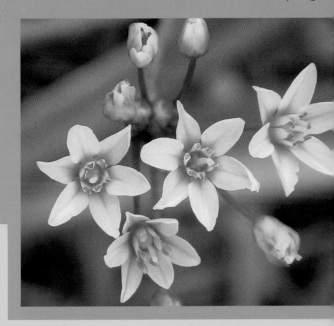

Anomatheca Laxa

An underutilized perennial that is both durable and beautiful.

A native of Southern Africa, this small flower is a subtle show-stopper in the southern coastal garden. Shines at Night grows from Charleston, South Carolina, southward to West Palm Beach, Florida. While coastal gardeners are more familiar with the red variety, there is also a rare white color. Although the leaves of Anomatheca strongly resemble the Lily, this plant is actually in the Iris family. Anomatheca is a bulb perennial and easily divides for sharing with friends. It is a somewhat unknown garden plant that is worthy of more attention.

The Shines at Night flower has six pointed petals that resemble a Star of David. For this reason, the Anomatheca is often planted outside synagogues as a floral representation of the symbol of the Jewish people. The flower of Shines at Night blossoms in autumn, corresponding with High Holy Days, a fall ceremony in the Jewish tradition.

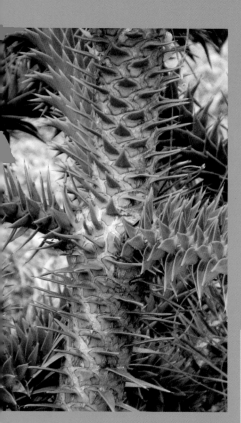

Araucaria Araucana
Monkey Puzzle or Chilean Pine

Evergreen

Araucaria Araucana

This South American native grows in both the Southern & Northern hemisphere.

An enormous South American native tree, the Monkey Puzzle gets its common name from its leaf arrangement. The short, stiff, triangle-shaped leaves grow without a petiole and feature a sharp point at the apex. The evergreen leaves face upward, allowing forest dwelling monkeys to climb into the tree by simply pressing the leaves flat against the trunk. Once in the tree, monkeys find it difficult to climb back down while avoiding the pointed leaves.

A conifer, the Monkey Puzzle is a cone-producing evergreen that can reach heights of over ninety feet. While sometimes called the Chilean Pine, this tree is only distantly related to true pines (Pinus), but is closely related to the Norfolk Island Pine (Araucaria Heterophylla).

The Monkey Puzzle was first imported from Chile to Hampton Court Palace, then home of Cardinal Wolsey, around 1521. Although no one is sure of its history at the palace over the next four hundred years, the Monkey Puzzle is growing on the Palace grounds today. It is grown as a unique ornamental all over Europe and South America, where it regularly attracts attention in the landscape.

Araucaria Heterophylla
Norfolk Island Pine

Evergreen

Araucaria Heterophylla

Norfolk Island Pine

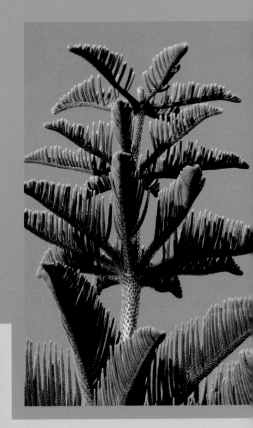

Many gardeners are familiar with the Norfolk Island Pine as a small, Christmas-time houseplant. The Norfolk Island Pine is a perfect table-top Christmas tree for an apartment. Americans buy this plant in red or green foil wrapper with a bow in early December. The majority of these trees are neglected or thrown out by the end of January. Few who bring the Norfolk Island Pine home for Christmas are aware of its history.

The Norfolk Island Pine is native to Norfolk Island, near modern-day Australia in the South Pacific Ocean. On its native island, the Araucaria is a massive, graceful and symmetrical tree. It grows with vigor to heights over one hundred and fifty feet along the rocky shoreline, while maintaining a uniform branch structure on a stately scale.

As sailors and traders began to explore the South Pacific region, many plants were brought home for use or study, and the Norfolk Island Pine was among them. Gardeners soon realized that this semi-tropical tree would not grow in colder climates, and specimens were brought inside to protect them for the winter. Somewhere along the way someone put a bow on one for decoration and a Christmas tradition was started.

In central and south Florida the Norfolk Island Pine (sometimes mistakenly called The Bunya-Bunya Tree) grows more like it does in its native area, tall and robust, towering over residential houses along the shore.

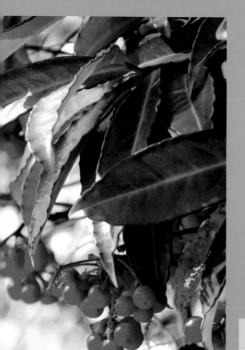

Ardisia
Marlberry or Coralberry

Spring to Summer

Ardisia

The Ardisia is a central plant in Chinese folk medicine.

Marlberries are a large family that includes many species, all native to China. There are tall, upright Marlberries and short, ground-cover varieties. Marlberries are naturalized along much of the southern east coast, but they are tender and will not take prolonged periods of freezing. Marlberry is sometimes called Coralberry, due to its red-colored, pea-sized fruit. Birds feed on the berries that persist into winter, and gardeners in Florida will eventually get volunteer Marlberries.

The planting of Ardisia is discouraged in south and central Florida, as it is invasive in these areas. In Georgia and South Carolina, however, Ardisia is far less invasive and is widely planted as an ornamental garden shrub. Ardisia can be seen growing wild in shady, alluvial areas, from Hilton Head to Brunswick.

In China, the Ardisia is a traditional plant with a long history. The Coralberry is listed as one of the fifty traditional herbal remedies in Chinese medicine. It is also a part of traditional Chinese folk stories that tell of the Ardisia flower holding spirits of healing and happiness.

Arundo Donax
Donax or Giant Reed

Evergreen

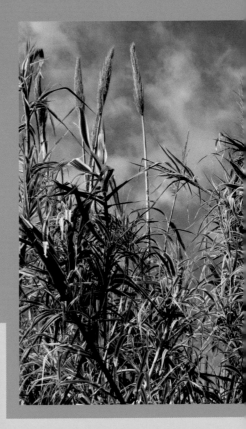

Arundo Donax

An enormous plant, Donax is both cultivated and wild.

A giant among plants, the Donax can easily tower over the coastal garden. The Donax is a massive ornamental cane grass that can reach heights of over thirty feet and form colonies that are perfect for obscuring airport noise, buildings or other unsightly views. The colonies are slow to form and can take years before they need their first control measures. The Donax, not recommended for small gardens or yards, is a great choice for large industrial plantings. It seeds on large, beautiful plumes in the fall, but the seeds are rarely fertile and propagation is almost exclusively vegetative.

Arundo Donax, which is native to southwestern Asia, the Arabian peninsula and parts of the Mediterranean, has been cultivated throughout southern Europe, northern Africa and the Middle East for thousands of years. The ancient Egyptians wrapped their dead in its leaves and burned its canes at the entrances to tombs. For centuries the reeds of Arundo Donax have been used for woodwind instruments such as the bassoon, clarinet, flute and oboe. Throughout history, the strong reed of Arundo has been used for many things from scaffolding to curtain rods. Gardeners have long used its ridged stems as a support trellis for climbing plants and vines.

In its native range, Giant Reed has been studied and grown in recent years for use in ecological industries as a renewable energy source.

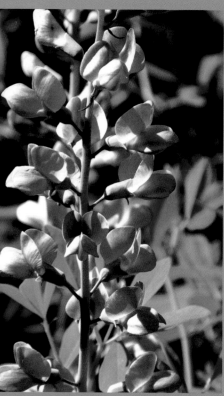

Baptisia Australis
Blue False Indigo or Blue Wild Indigo

Spring to Summer

Baptisia

An invasive yet beautiful wild flower in the southern seaside region.

Baptisia Megacarpa Alba

Baptisia can be seen in white, yellow and purple.

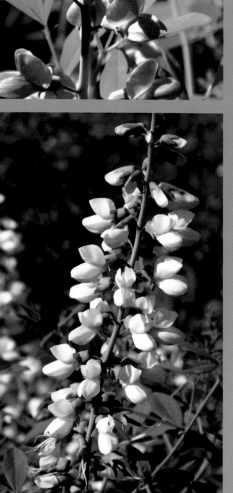

Baptisia Australis, commonly known as Blue Wild Indigo or Blue False Indigo, is a herbaceous perennial in the Legume or Pea family. It is native to much of the central and eastern United States. Baptisia is a popular garden perennial due to its its low maintenance and attractive deep blue flowers that emerge on tall spikes in the late spring.

The name of the genus is derived from the Greek word *bapto*, meaning "to dip" or "immerse." The specific name, Australis, is Latin for "southern." Additional common names of this plant include Indigo Weed, Rattleweed, Rattlebush and

Blue False Indigo or Blue Wild Indigo (*continued*)

Horse Fly Weed. The common name, Blue False Indigo, is derived from its use as a substitute for the superior dye-producing plant, Indigofera Tinctoria.

Baptisia Australis grows best in lime-free, well-drained, stony soil in full sun to part shade. Naturally it can be found growing wild at the borders of woods, along streams or in open meadows.

Several Native American tribes made use of the plant for a variety of purposes. The Cherokees used it as a source of blue dye, a practice later copied by European settlers. They also used the roots in teas as a purgative or to treat tooth aches and nausea. The Osage made an eye wash with the plant. A cold tea was given to stop vomiting, a root poultice was used as an anti-inflammatory, and bits of the root were held in the mouth to treat toothaches. Baptisia species are being investigated for use as a potential stimulant of the immune system. A decoction of stems has been used for pneumonia, tuberculosis and influenza. Tips of stems combined with twigs of the Utah juniper, Juniperis Osteosperma, have been used as a kidney medicine. Baptisia has also been used as a tea (tisane) for smallpox and externally as a cleansing wash. Trials using the extract of Baptisia to treat typhoid fever were made in the early 19th century.

The pods are utilized in dried arrangements. Wild Blue Indigo is said to repel flies when kept near farm animals. Hang a bunch of Baptisia off the tack of a working animal. The plant is also used in witchcraft for spells or rituals of protection.

Bauhinia Blakeana
Hong Kong Orchid

Spring

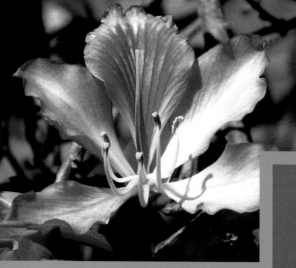

Bauhinia

Hong Kong Orchid is steeped in folklore and history.

Rare north of Florida, Hong Kong Orchid can be seen throughout the Sunshine state.

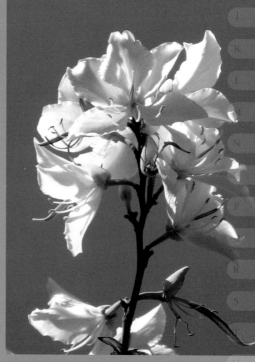

Honored in many ways in its native Hong Kong, the Bauhinia has become a symbol for that Asian region. The most prominent of the honors is its use on the Hong Kong state flag. A stylized Bauhinia flower with five petals on a red field has graced the official flag since the fourth of April, 1990. The red field represents China and the Bauhinia flower represents Hong Kong; together they are the symbol of a unified Hong Kong. The same stylized Bauhinia flower is also used on the Hong Kong state emblem.

Golden Bauhinia Square is a public park in Wan Chai North, Hong Kong. This symbolically important square was named for the large statue of a golden Bauhinia Blakeana at the square's center. The six-meters-tall sculpture is a gilded Hong

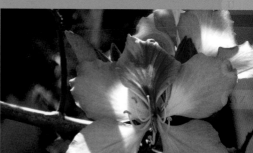

Bauhinia Blakeana
Hong Kong Orchid (*continued*)

Spring

Bauhinia

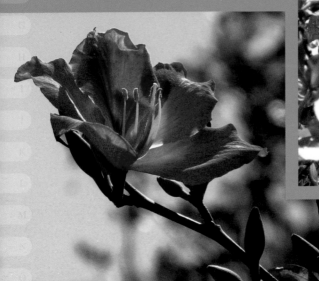

Bauhinia

Bright colors are a trademark of the Bauhinia.

Kong Orchid flower on a red granite base, reflecting the symbolism of the flag. This magnificent sculpture has become an important landmark for the people of Hong Kong in the years following reunification. In July 1997, ceremonies for the exchange of Hong Kong and the establishment of the Hong Kong Special Administrative Region were held at the Hong Kong Convention and Exhibition Center, where Golden Bauhinia Square is located. The official Hong Kong state flag is raised over Golden Bauhinia Square every day during a morning ceremony; in recent years the square has become a major tourist attraction for thousands of visitors to Hong Kong.

The Hong Kong Orchid tree was discovered on Hong Kong Island near the ruins of a home in 1880. In 1908, the Bauhinia was given the botanical genus name Blakeana after Sir Henry Blake, the British Governor who served in Hong Kong from 1898 to 1903. The Hong Kong Orchid tree has been propagated by the State Botanical Garden of Hong Kong for over a century. Several dozen varieties of Hong Kong Orchid are in cultivation today.

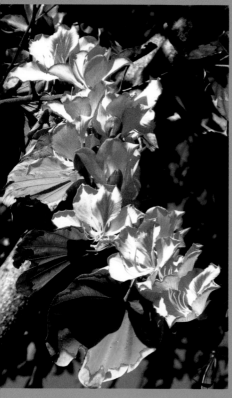

Bauhinia

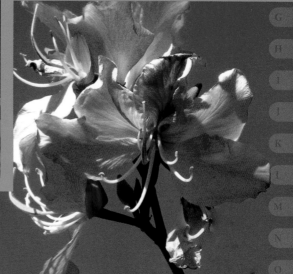

Bauhinia

Hong Kong Orchid flowers in the spring.

While gardeners north of St. Augustine, Florida, may be unfamiliar with this beautiful spring flowering tree, the Hong Kong Orchid is well known to south and central Florida gardeners who have grown it for years. The frost-sensitive Bauhinia is a truly tropical tree that is ubiquitous along most of the east and west coasts of Florida. In March and April, the Hong Kong Orchid boasts many six-inch flowers at the tips of its branches, with a color palette that ranges from pure white to deep purple. The evergreen leaves of the Bauhinia are unique as well,

displaying an interesting lobed and folded configuration. The overall mature size and branch structure of a Bauhinia is comparable to the unrelated Crepe Myrtle. They both require only occasional light pruning to clean out dead branches or suckers around the base. A compost mixture applied to the Hong Kong Orchid Tree each January will provide Florida gardeners with years of enjoyment.

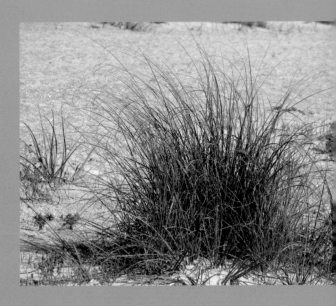

Beach Grass

Ubiquitous along southern beaches, beach grasses are both beautiful and functional providing beach erosion protection and wildlife habitats.

Bellamy Mansion

The Bellamy Mansion gardens are historically important. They provide an example of traditional southern coastal landscapes.

Bismarckia Nobilis
Bismarck Palm or Silver Frond Palm

Evergreen

Bismarckia

This enormous and unique tropical Palm is frost sensitive

A massive and majestic palm, the Silver Frond Palm should be the centerpiece for any large tropical garden. This palm can be seen gracing gardens from Key West to Titusville, Florida. They are quite frost sensitive and virtually disappear as far north as Daytona Beach. The Bismarck Palm has certainly earned its botanical name *Nobilis*, which means noble in Latin.

A relatively new palm introduction to most American gardeners, the Bismarck Palm has a long history in its native Madagascar, an island nation off the east coast of Africa. In traditional Madagascarian folk religions, this palm was considered to be one of the highest offerings to the gods and was therefore used as an altar decoration. It was presented as a backdrop behind kings, with the thought that its powers would elevate the kings to be on par with the gods.

The Bismarck Palm is covered in soft, wooly hairs that were traditionally harvested and used as stuffing in upholstering the thrones of kings and chairs for visiting dignitaries. The fibers are still sought-after today.

Blechnum Gibbum
Dwarf Tree Fern
Evergreen

Blechnum This tropical Fern is sometimes known as the Tree Fern.

Native to Fiji, this tropical fern is a must for any south Florida gardener. Dwarf Tree Fern is a slow-growing shade lover and will take years to develop a trunk, but a patient grower will be rewarded with an awe-inspiring specimen. In its native Fiji, it is associated with patience, tranquility and serenity.

Growers in Florida, north of West Palm Beach, can enjoy the Dwarf Tree Fern as a protected-patio plant. The Dwarf Tree Fern can be grown as a houseplant anywhere in America.

Bougainvillea

Spring to Summer

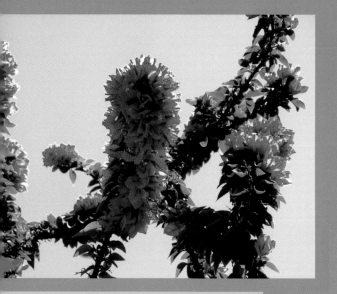

Bougainvillea

Tree Bougainvillea has delighted tropical gardeners for generations.

Bougainvillea is available in a wide variety of colors, and in tree or shrub form.

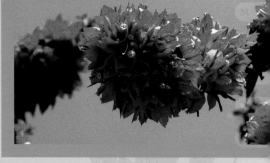

The botanical name of this bracting shrub is taken from a French navy admiral and explorer, Louis Antoine de Bougainville.

Southern gardeners have planted Bougainvillea, a semi-tropical shrub, for years with great success. Most gardeners know it as a scandent, sprawling plant that climbs over fences, walls and mailboxes with ease. There is, however, a tree-form Bougainvillea that has arching upright branches which can support itself unaided by a trellis. Pictured here, in Cocoa Beach, Florida, is a tree variety that resembles a Crepe Myrtle at a distance. The tree form Bougainvillea holds the blossoms in clusters at the ends of the branches, differing from the regular shrub Bougainvillea. Like all Bougainvilleas, the tree form produces bracts, or colored leaves, as opposed to true petals. The Dogwood and Poinsettia are also examples of bracting plants.

Bouvardia Ternifolia

Scarlet Bouvardia or Firecracker Shrub

Summer

Bouvardia Ternifolia The Bouvardia is beautiful, long lasting and easy to grow.

Scarlet Bouvardia is a perennial shrub with trumpet-shaped flowers in brilliant shades of red and scarlet. The flowers are about two inches long and flare out at the tips in four evenly divided segments. The flowers are arranged in clusters at the ends of numerous upright branches. The flower shape resembles a Cestrum. The Bouvardia's spectacular red corolla attracts and provides nectar for hummingbirds. The Scarlet Bouvardia, a Texas native, does best in dry, hot areas and should never need watering in the east coast landscape.

The Spanish name for Bouvardia is *Flora de Trompetilla*, which means "The little trumpet flower" and refers to the shape of the flower.

Bouvardia is a close relative of both the Coffee plant and the Gardenia. According to one old-wives'-tale, "only cut the flower of the Bouvardia if you want your mother-in-law to stay two more weeks."

Brahea Armata

Blue Hesper Palm

Evergreen

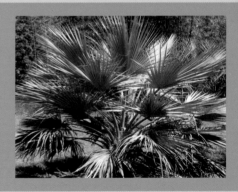

Brahia Armata

A west coast Palm that grows well in the Savannah, Georgia area.

Blue Hesper Palm is native to Baja California, Mexico. Though a west coast native, Blue Hesper Palm grows with vigor along the southern east coast. Palm growers have had success with the Blue Hesper from Hilton Head Island to Florida. Like all palms, the Blue Hesper is slow growing, but patience is rewarded handsomely with a majestic show plant. Many consider the Blue Hesper Palm's blue fronds to be the best shade of blue in the palm world.

The stout, thick trunk of the Brahea holds a large cluster of upright fan-palm-shaped fronds that display, in full sun, shades of silver that blend into blue. The Blue Hesper Palm will eventually attain heights over twenty feet.

Breynia
Snow Bush

Spring to Fall

Breynia

A colorful, fun and interesting plant for children's gardens. The Snow Bush is frost sensitive.

Snow Bush is oddly named, given that it is a truly tropical shrub that can't stand temperatures below 45 degrees F. This medium-sized, motley colored shrub will only grow as an evergreen in coastal regions south of Cocoa Beach, Florida. Surprisingly, it likes to be in a shady spot. Snow Bush has been grown throughout Hawaii and the South Pacific region for decades, having only recently been introduced to Florida.

Bromeliaceae

Bromeliad

Year Round

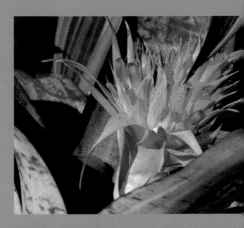

Bromeliaceae

Bromeliad makes a wonderful container plant in light frost areas.

The Bromeliad is a garden plant in central & south Florida.

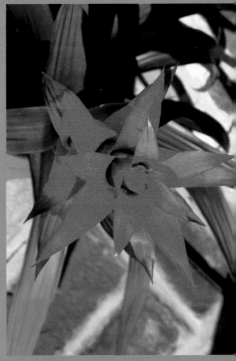

The most widely known member of the Bromeliaceae family is the pineapple, which was first "discovered" by Christopher Columbus on his second voyage to the new world in 1493. Columbus took pineapples back to Spain where they were quickly introduced across the known world, finding particular success in India. Pineapples get their common name from their resemblance to Pine cones. Today, millions of pounds of this tropical fruit are eaten each year in America alone.

The second most recognized member of the Bromeliad family is Spanish Moss (Tillandsia Usneoides), which looks nothing like the Pineapple as it dangles from Live Oak Trees in the southern coastal region.

Bromeliaceae

Spanish Moss, a Bromeliad family member, is well known for its historical and ghostly folklore. Spanish Moss stories include pirates, soldiers, Indians and automobile barons. The rarely seen Spanish Moss flower is pictured here.

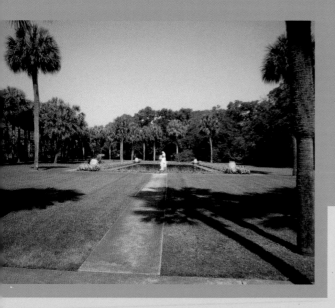

Brookgreen

The magnificent views in Brookgreen Gardens, at Murrells Inlet, South Carolina, attract visitors from around the world. Brookgreen Gardens is one of the oldest botanical gardens on the east coast.

A
B
C
D
E
F
J
K
L
M
O
P
Q
R
S
T
V
W
XYZ

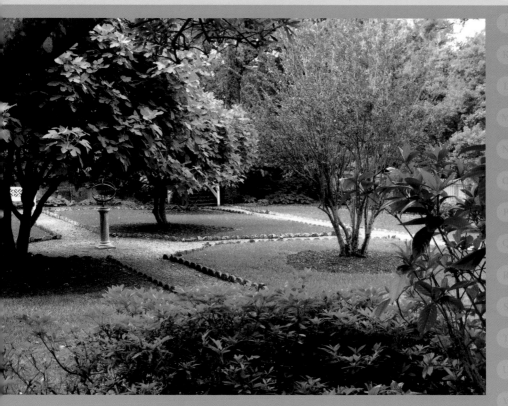

Burgwin – Wright House

The historically significant gardens of the Burgwin-Wright House in Wilmington, North Carolina. Pomegranates and Camellias are prominently featured at this historic home near the Cape Fear River.

Calliandra Haematocephala

Dwarf Powderpuff or Chimney Sweeper's Broom

Summer

Calliandra Haematocephala

Exceptionally rare and exceptionally beautiful the powder puff preforms best in dry soil and part shade.

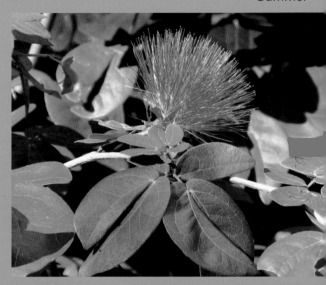

Powderpuff is a rapidly developing shrub that grows as wide as it does tall. The buds look like red and juicy raspberries. The red Powderpuff flowers are attractive to hummingbirds, butterflies and nature enthusiasts. Robust, medium-green leaves, which close at night, share the secret that this flowering shrub is a Mimosa relative.

A semi-tropical shrub, the Powderpuff does best in warm climates or protected areas. Powderpuff needs to be watered from underneath the foliage, as the flowers do not like to be wet. Fertilizing should be done in spring and early summer with a regular organic mix. Chimney Sweeper's Broom is also a popular houseplant, where, with proper care, it can provide a beautiful display to any living room or patio.

Powderpuff is associated with beauty in folklore. Tales tell of its use to attract a wife. Young men would wear it on their lapels and when a lady saw it she would fall madly in love and quickly accept his proposal of marriage.

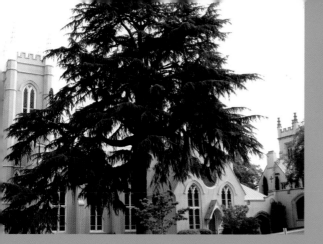

Cedar of Lebanon

Evergreen

Cedrus

The Cedar of Lebanon has deep roots in both the Christian and Islamic traditions being mentioned in both the Bible and the Koran.

The Cedar of Lebanon, native to the Middle East, was important to several ancient civilizations, including Hebrews. Jewish tradition tells how Moses ordered the Kohens, or priestly class, to use Cedar of Lebanon oil in the service of Brit Milah. Jewish tradition also tells how the Cedar of Lebanon was the chosen wood to construct Houses of Worship, including King Solomon's Temple and the palaces of David and Solomon. According to the Talmud, Jews once burned Cedar of Lebanon wood to celebrate Rosh Hashanah. The Cedar is so prominent in Jewish culture that it is scribed 75 times in the Hebrew Scriptures, commonly known in biblical terms as the Old Testament.

Cedar of Lebanon was among the best wood available to sea-faring Phoenicians who lived in Canaan. Therefore, it was used for building their passenger and war ships, as well as houses, palaces and temples.

Ancient Egyptians used the resin found in the Cedar of Lebanon in part of their mummification process. Archeologists have recently discovered cedar wood in several of the Pharaohs' tombs.

In ancient Greek history, the Cedar of Lebanon was used to construct the Parthenon. Columns of the Parthenon were made of granite drums that were stacked to form the complete column. Because each drum had massive weight, pins made of Cedar wood were used at the center of each drum to align and secure its columns. In When restoration and preservation began on the Parthenon in 2008, highly trained workers separated the columns and found cedar pins perfectly preserved, 2500 years after the original construction, and the cedar pins even retained their scent.

Pliny the Elder, an ancient Roman naturalist, once noted that the Cedar of Lebanon grew over 130 feet tall. Because of their great height, Romans venerated the cedar and dedicated them to their gods.

The official present-day flag and state seal of Lebanon feature the Cedar of Lebanon as its centerpiece, alluding to the importance of the cedar in Lebanese culture.

A Cedar of Lebanon was planted, in 1850, on the grounds of historic St. James Church in Wilmington, North Carolina.

An evergreen conifer, the Cedar of Lebanon is a tough, durable tree with history as long as civilization itself.

Weeping Katsura

Spring to Fall

Cercidiphyllum Japonicum

The Weeping Katsura is an excellent choice for Asian themed gardens.

Somewhat unknown to American gardeners, the Katsura tree has been grown as an ornamental in Japan and China for centuries. It is presented both for its attractive heart shaped leaves and for its prominent fall color. While the original species of Katsura is upright and reaches heights of twenty feet, several weeping varieties have come into cultivation in recent years.

The botanical name for Katsura, Cercidiphyllum Japonicum, is taken from the leaves resemblance to the Redbud (Cercis) and Japan, its native range. The golden yellow fall foliage of the Weeping Katsura has a scent that is reminiscent of cinnamon. Katsuras are not fussy beyond needing consistently moist soil for the lifetime of the tree, which can be over one hundred years.

Cestrum Aurantiacum
Yellow Cestrum

Spring to Summer

Cestrum Aurantiacum

The Cestrum is a good choice for attracting humming birds.

Ajuga makes an excellent companion plant for the Cestrum.

A yellow-flowering shrub native to Guatemala, the Yellow Cestrum is a great addition to any coastal garden in Georgia or Florida. While the Cestrum is a die-back shrub in Georgia and north Florida, and will return with vigor each spring, it is completely hardy south of Daytona Beach, Florida. *Cestrum Aurantiacum* is a daytime-flowering shrub, but there is also a night-blossoming Cestrum.

Cestrums blossom in the spring, producing round clusters of small, fragrant, trumpet-shaped flowers borne on sprawling, irregular branches. Cestrums are an easy-to-care-for shrub needing only full sun and regular watering. The Cestrum is known for its ability to attract several varieties of butterflies and hummingbirds.

Tropical folk stories tell how forest spirits were engaged by the gods through the sound and scent of Cestrum flowers. The gods would use Cestrum flowers as trumpets to speak to spirits, and spirits would respond by giving native peoples good harvests and plenty of rain.

Chanaecyparis Obtusa
Hinoki Cypress

*Chamaecyparis Obtusa -
Hinoki Cypress*

The wood of the Hinoki Cypress has
been used for furniture & musical
instrument making in its native Japan
for generations.

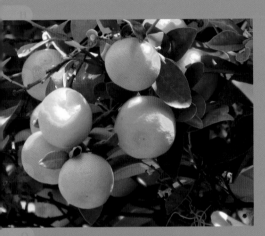

Citrus ssp.
Orange

Winter to Spring

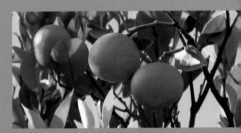

Florida's Citrus crop is a leading
agricultural industry.

All Citrus is bee-pollenated, and
preserving the bee population is
crucial to Florida's economy.

Many gardeners do not realize
that many staple food crops, like
citrus (oranges, grapefruit), are
pollinated by bees. When gardeners
across the South began to use
pesticides in preceding decades,
growers of citrus in Florida noticed
a drop in yields, which lead directly
to higher prices at grocery stores
and farmers' markets. Common
pesticides used by home gardeners
can, in large numbers, kill bee
populations. While bees and other
critters are annoying to us in the
garden, they play a vital role in
perpetuating the flowers and fruits.

Garden gloves, long sleeves and
veils will protect a gardener without
using chemicals that damage the
balance of nature. As they learn to
garden organically, people will see
more flowers and fruit and lower
prices at the store. Buying honey
from a local maker will help to
sustain the bee population.

Cleome or Spider Flower

Summer Annual

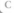

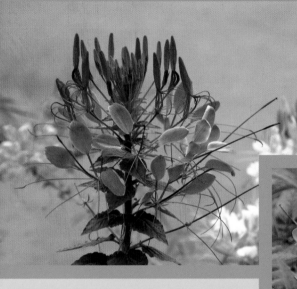

Cleome

Cleome is a classic garden annual.

Cleome is an annual bedding plant for the full-sun garden. Strange, lacy flowers come in many colors and wave just above Daylilies and Verbena. Most coastal gardeners rely on Cleome for variations in texture among their summer annuals. Spider Flower also brings birds, bees and butterflies to the landscape. Planted in large groups, the Cleome is a show-stopper for garden visitors.

Thomas Jefferson, our third president, is said to have planted Spider Flower in the gardens of Monticello. Jefferson would have gathered the seeds of the Spider Flower in the fall and sown them in a cold frame over the winter months to have a supply for the next year.

Clerodendron or Glory Bower

Summer

Clerodendron

The fuchsia Clerodendron pictured here is a vine variety.

The Lavender/Indigo Clerodendron is a hardy perennial in the coastal garden.

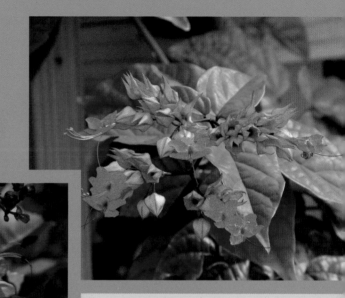

Whether they are vines or low-growing perennials, all Clerodendrons have brightly colored flowers that blossom in warm weather. The scent is one of the Clerodendrons most sought-after qualities, with all parts of the plant being strongly aromatic. The Fragrant Garden for the Blind, in Savannah, Georgia's Forsyth Park, features fragrant plants specifically chosen for their appeal to blind people. The garden is planted with many old fashioned plants, including the Glory Bower, that are more heavily scented than new hybrids bred for cold resistance. The Clerodendron can be a prolific spreader under moist semi-shady conditions, but is quite manageable in the average garden.

While most gardeners think of Clerodendron as a zone 8 or 9 perennial, the Clerodendron can be seen growing in zone 7 at the Lewis Ginter Botanical Garden in Richmond, Virginia.

The Clerodendron was also featured in author Roy Heizer's second book, *Atlanta's Garden Plants*.

Cnidoscolus Stimulosus
Spurge Nettle or Tread Softly

Spring to Summer

Cnidoscolus Stimulosus

The common name, Tread Softly, is a warning to the barefoot gardener.

The only difference between a weed and a garden flower is placement, and many coastal gardeners consider this wildflower a weed. While Spurge Nettle has innocent-looking, small, white flowers and Maple-like leaves, closer inspection reveals that this plant has hundreds of tiny hairs that act as needles. These needles are used by the plant as protection against foraging and damage. When touched or brushed by a person or animal, the hairs cause painful, irritated spots. Inflammation can last several minutes in some, while in others the attack can be much more serious. The common name, Tread Softly, is a warning to anyone who wants to touch this plant with bare hands or step on it with bare feet. However, in a natural area, the Spurge Nettle is a low-growing, pretty, perennial flower.

A fierce competitor on the forest floor, Spurge Nettle is not only armed but is a prolific reproducer, quickly becoming invasive in the garden. An herbicide is the only effective method of controlling Spurge Nettle in the lawn and border.

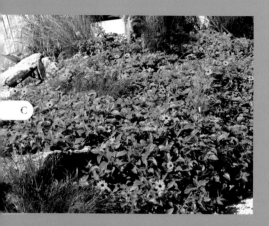

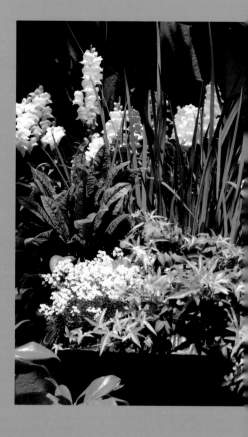

Coastal Landscape ABOVE

Firecracker plant (Ruellia) and Beach Sunflower (Helianthus) make this coastal landscape pop with color.

Coastal Container Garden RIGHT

A fine example of Coastal Container Gardening. Ivy, Rumex and Snapdragons are featured in this arrangement.

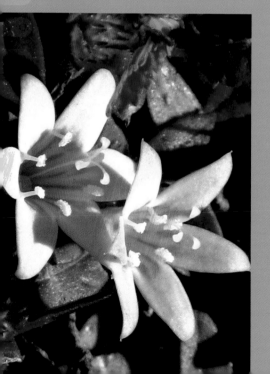

Coastal Wildflower LEFT

Coastal Swamp BELOW

Seaside habitats can vary wildly, with environments ranging from beach front properties to shady swamp lands. The wooded swamp pictured here is a wonderful example of coastal biodiversity.

Coccoloba Uvifera
Seagrape or Sea Grape Shrub

Year Round

A B C D E F G H I

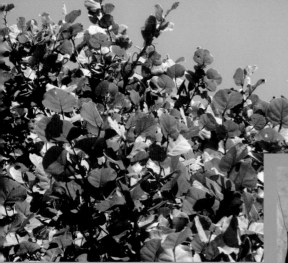

Coccoloba Uvifera

In youth the Sea Grape is a medium sized shrub, but as it ages it turns into an enormous sprawling multi-trunked tree.

Sea Grape leaf

Growing right on the beach along the east and west coasts of Florida, the Sea Grape adds year round beauty to coastal cities such as Miami, Clearwater Beach and Tampa. This Buckwheat relative grows in tropical-coastal regions from central Florida south throughout the Caribbean. Coccoloba Uvifera is one of the most common plants in warm climate areas throughout the Americas; while mostly known as a beach plant, the Sea Grape will also grow inland across Florida.

The Sea Grape gets its botanical name, Coccoloba Uvifera, from the shape of its leaf, and from the word Uva, which means Grape in Spanish. The Family botanical name, Polygonatum, refers to the many pronounced nodes along the stems of some members of this species, such as the Seagrape. A node is a term that indicates where a leaf or branch will emerge along the stem of a plant. The name Polygonatum is taken from the Greek with *poly* meaning many and *goni* meaning knee or joint.

The small grape-like fruit of Sea Grape is used to make jams and jellies in tropical regions all over the world. The fruit can also be eaten fresh off the shrub, but is noted

Coccoloba Uvifera

ABOVE: Sea Grape grows equally well in sun or shade.

LEFT: The Sea Grape provides tropical gardeners excellent fall color, with a pallet including yellow, burgundy and lime.

BELOW: Sea Grape

for being sour. Large clusters of fruit begin to develop in late March and will mature in early May. A single mature Sea Grape Shrub can produce over two hundred pounds of Grapes in a season.

The Sea Grape is often planted as a small shrub, but given enough time, it will grow into a sprawling, multi-trunked tree spreading over thirty feet in diameter. It is one of the few tropical plants to develop any fall color, and can have shades of red, burgundy, lime, orange and even silver throughout the winter and early spring. The fleshy, round leaves emerge in late spring, showing off shiny, brilliant shades of burgundy.

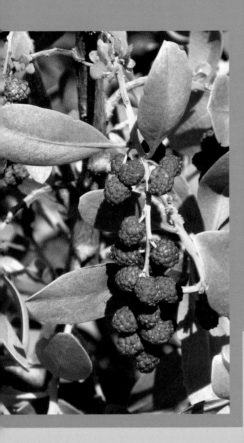

Conocarpus Erectus var. Sericeus

Florida Buttonwood or Silver Buttonwood

Spring to Fall

Conocarpus

A ubiquitous landscape plant in tropical Florida, the Silver Buttonwood is widely known for its floating fruit.

A member of the Mangrove family, Silver Buttonwood is a truly tropical shrub that has a range from coastal areas south of Daytona Beach all the way to Key West, Florida and into the Caribbean Sea. They also grow along the Gulf side of the Florida peninsula. Because the fruit floats, Silver Buttonwood has been distributed to coastal areas all over the tropical regions of the world.

Silver Buttonwood is a hardy multi-trunked shrub that will grow to fifty feet tall, but most specimens are between three to nine feet in height. Unlike the regular Green Buttonwood,

Silver Buttonwood leaves are covered with fine hairs that give it a distinctive, shiny-silver appearance. The fruit is a small, brown-to-rust-colored ball that hangs in open clusters in the spring. A single fruit ball contains several tiny seeds. Silver Buttonwood is a landscaping regular, and can be seen complementing Eucalyptus or contrasting Hibiscus in tropical gardens. Conocarpus makes an excellent small, beach-front tree creating twisted, natural sculptures as it grows in the nearly constant wind.

Early settlers throughout Florida found that the wood of the Silver Buttonwood could be used to smoke meat and fish. This plant was traditionally used in making charcoal. Due to ornamental plantings, this shrub has become naturalized in Hawaii.

Cordyline
Ti Leaf

Spring to Fall

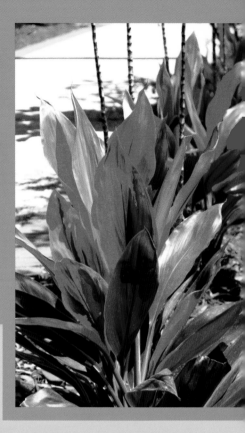

Cordyline

According to folklore, Ponce de Leon once mistook Cordyline for the waters of the fountain of youth.

Cordylines are native to the South Pacific, from New Zealand north to Hawai'i. This unique-looking foliage is most often grown for its large leaves and tropical appearance. The Cordyline does flower, but the flowering is irregular. Colors range from dark green to burgundy, and some are solid or variegated. Florida gardeners can grow Cordyline outside year-round, while further north it is a popular container plant for inside, winter color.

Polynesians first brought Cordyline to Hawai'i in the form of cuttings that were easy to transplant. Traditionally, Hawaiians have cooked and eaten the large tuberous roots as well as having used it for medicinal purposes. Hawaiians have used the Ti Leaf for everything from Hula skirts and dinner plates to brooms.

Spaniards are thought to have brought Cordyline to the new world in the late 1600s. In a bizarre ritual, the Cordyline was planted at graves of enemies of the Spanish crown. The red-to-burgundy leaves, which are upright and pointed, were said to represent the flames of Hell where the deceased were burning after defeat. When Spain ceded Florida to Britain in the mid-1700s, Cordyline remained and became a staple in tropical gardens.

Cornus Florida
White or Pink Dogwood

Spring to Fall

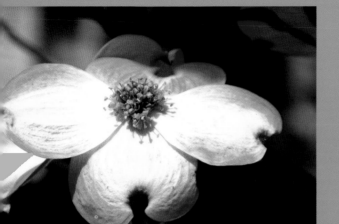

Cornus Florida

The Pink Dogwood is one of America's favorite landscape trees, and can be seen growing from Florida to Minnesota.

Highly revered for its manageable size and ease of care, the Dogwood is available in white, pink or yellow varieties.

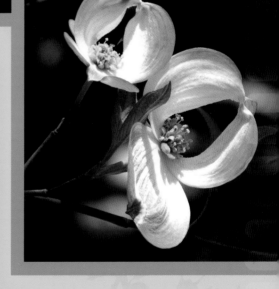

Despite the word "Florida" in the botanical name, Dogwoods are rare in southern coastal regions of America. Cornus species are much better suited for cooler climates and grow in abundance along the mid-Atlantic states. In fact, Dogwood is the state tree of Virginia and the state flower of both North Carolina and Virginia.

The Dogwood is a central character in one of Christian folklore's most widely known stories. Accordingly, the Dogwood was once a massive tree used to make the cross on which Jesus was crucified. The tree asked Jesus for forgiveness for being used for such a purpose, and Jesus forgave it. Jesus then turned the Dogwood into the small, irregular tree we know today so that it could never again be used as a cross.

In Victorian time, the Dogwood's inflorescence was used in courting rituals, while in modern time the Dogwood is widely used as an ornamental tree in urban landscapes.

45

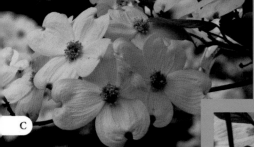

C

Cornus Florida

ABOVE: The classic Dogwood flower.

LEFT: A cerulean sky provides the perfect backdrop for the Pink Dogwood.

BELOW: The Dogwood provides seaside gardeners with stunning fall color.

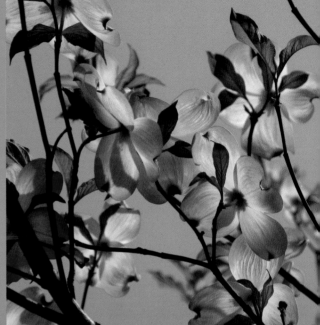

In October, the Dogwood tree develops fall color accented by bright red berries. Appreciated for its size and profuse flowering, Cornus Florida can be seen each spring along the streets and in the parks of Norfolk, Richmond and Virginia Beach, Virginia.

Cortaderia Selloana

Pampas Grass

Year Round

Cortaderia Selloana

Native to South America, Pampas Grass is one of the largest ornamental grasses commonly seen in coastal regions.

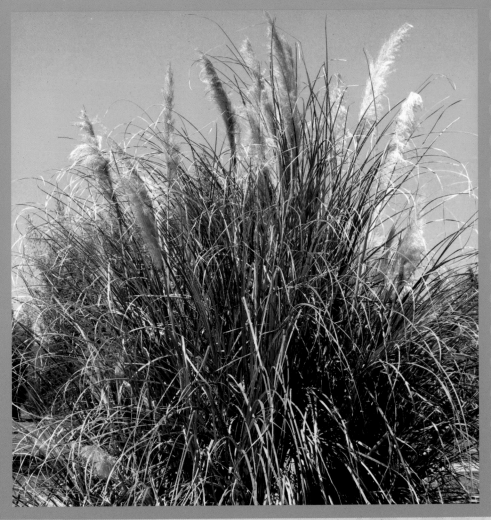

The largest of the ornamental grasses grown along the east coast, Cortaderia is as tough as it is beautiful. Pampas Grass is native to southern South America, including an area known as Pampas, for which it is named.

Daphne or Winter Daphne

Evergreen, Spring

Daphne Odora

A classic, old fashioned, evergreen, garden shrub. Winter Daphne flowers between Christmas and Saint Patrick's day.

A classic southern garden shrub, the Winter Daphne has been gracing gardens since the late 1600s. Antebellum gardens filled with traditional plants were revered in the south, and their layout can be traced back to the formal gardens of England and France. Historically, the aristocracy of Europe would import exotic foreign plants from China and Japan, and grow large ornamental gardens as a show of wealth. The tradition of status gardens continued in the New World.

As cotton, rice and tobacco brought wealth to southern coastal states, large homes were built for the barons of agricultural commerce. These homes typically had large ornamental gardens and the Daphne Odora, with its fragrant flowers, was prominently displayed. Winter Daphne, native to China, would have been imported in the years before the American Revolution.

An evergreen, the Winter Daphne gets its common name from its ability to look fresh and alive, even in the dead of winter. In the early spring, Daphne displays small, loose clusters of light pink flowers. The heavily scented flowers of the Daphne attract bees, birds and butterflies. While most traditional antebellum gardens would have featured the original, all-green variety, a variegated form is available for modern gardeners. Unfortunately, the Daphne is a short-lived shrub that will rarely live beyond a decade.

Delphinium
Larkspur

Summer, Annual

A western wild flower that thrives as an annual along the east coast.

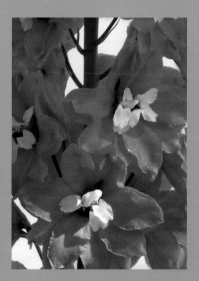

Delphinium

A rare blue specimen.

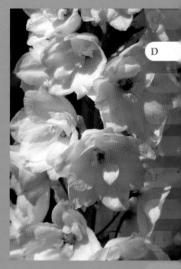

Delphiniums come in a variety of colors, those pictured here as well as buttery yellow, pink and violet.

An elegant annual in the summer garden, Delphinium is one of the gardener's few choices for blue blossoms. Waves of dark green, fully serrated foliage are accented with spikes of tall, usually blue-purple flowers in mid-summer. Because of their height and dramatic appearance, Delphiniums are almost always planted in groups at the back of a border. There are perennial varieties of Delphiniums available online through seed sources, but most varieties are tender at best. The botanical name comes from the Greek word for Dolphin, referring to the petal and sepal configuration. The common name, Larkspur, comes from the flower arrangement. The flowers are pollinated by both butterflies and bees.

Delphiniums thrive in coastal areas with relatively warm summers and plenty of rain; they struggle in dry conditions. Delphiniums are available in a wide range of sizes, from less than two feet tall to over six feet. Flower colors include blue, purple, red, white, and yellow. Delphinium begin flowering in late spring or early summer and continue well into the fall. In the western United States, Larkspurs are known as a self-seeding, meadow wildflower.

In France, scholars who were taxing their eyes over volumes of text were advised to keep the Larkspur flower on their desks, and to glance at it often. To look at the mid-summer fires through bunches of Larkspur meant trouble-free vision for the year to come.

Twinspur or Tongue Flower

Summer, Annual

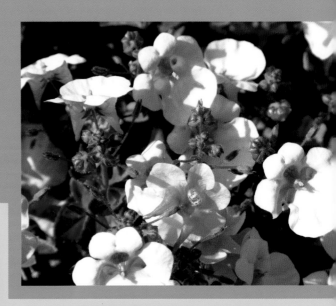

Diascia

A low growing garden favorite.

This small flower is called Twinspur, because it has two protrusions on the back. Since it draws bees, butterflies and moths to its abundant nectar, the Twinspur is a staple in wildlife and nature gardens. The soft-colored flowers emerge in early spring and will reblossom all summer, with ample sunlight and proper deadheading. There are several types of Twinspur, some mounding, some trailing and others more upright in structure. Gardeners often associate the Twinspur with good fortune, luck and serendipity.

A South African native, the Tongue Flower is related to the Snapdragon and Nemisia, two other garden favorites. Tongue Flower gets this common name from the relatively large lower petal section that looks like a tongue being stuck out. Gardeners along the east coast grow the Tongue Flower as an annual, but this mounding plant can reseed itself under mild winter conditions. The Tongue Flower can also be grown with success in hanging baskets, easily withstanding salt spray and harsh winds in coastal regions.

Dionaea Muscipula
Venus Flytrap

A
B
C
D
E
F
G
H
I
J
K
L
M
N
O
P
Q
R

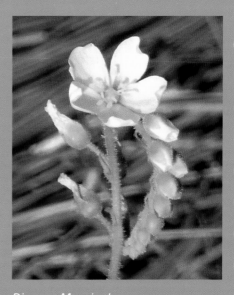

Dionaea Muscipula

The stunning white flower of the Venus Flytrap displays a sweetness and innocence that belies its carnivorous nature.

"Southern Hospitality" by Wilmington artist Paul Hill and glass artist Stan Harmon, depicts the Venus Flytrap, a carnivorous plant native only in the boggy area within a 75 mile radius of Wilmington. This sculpture was given to the city of Wilmington by the residents of Old Wilmington, Inc. October 2010. In 2005, Venus Flytrap was named the official North Carolina state carnivorous plant.

Dionaea Muscipula

Venus Flytrap

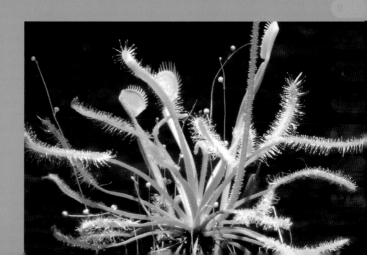

Doronicum Caucasicum
Leopard's Bane

Spring to Summer

Doronicum

This Aster family member is a favorite of southern coastal gardeners, while leopards dislike it immensely.

A small, yellow flower reminiscent of the Daisy, Leopard's Bane is a cool-season perennial for the mid-Atlantic state of Virginia. Leopard's Bane does not like a hot, southern climate and will perform best in gardens that have somewhat cooler summers. The Leopard's Bane leaf shape will remind the gardener of Violets. This bright, fun, perennial flower is one of the first to come out in the spring, giving anxiously awaiting gardeners some of their first flower color of the season. Coral Bells and Columbine are recommended as companion plants. The flowers, stems and leaves of Doronicum are highly poisonous to humans.

In the 18th century, leopards were beginning to travel the world, visiting royal gardens and developing a reputation for judging the finest displays of flowers. They were, of course, looking for the fastest growing plants. By the early 19th century, leopards were said to dislike this flowering perennial so strongly that Spotty, King of all Leopards, sent a letter to United States President Madison, in 1812, asking that it be banned from the White House gardens. Gardeners have called this plant Leopard's Bane ever since.

Driftwood

Driftwood adds a sculptural element to beachfront beauty.

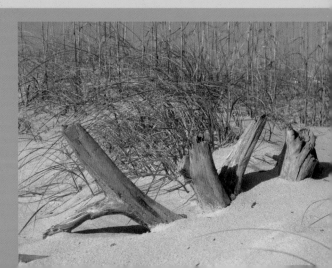

Erysimum
Wallflower

Spring to Summer

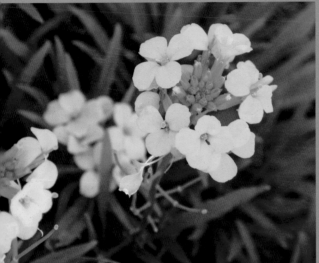

Erysimum Citron

Wall Flower is a durable flowering perennial.

Erysimum Linifolium

Jakob Dylan named his band *The Wallflowers* in honor of this plant.

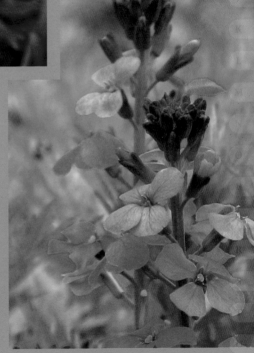

Wallflowers are native to many parts of the world, including the Americas. Wildlife gardeners love this medium-sized perennial for its ability to attract all manner of butterflies, moths, bees and dragonflies. These garden critters pollinate the flowers that show a rainbow of colors in the spring and summer. Wallflowers are one of only a few garden plants that are deer-resistant.

A reliable perennial, Wallflowers have been grown by gardeners for generations. The botanical name, Erysimum, derives from Eryo, to draw or to draw out, and refers to the plant's alleged ability to draw toxins out of the body. In the European flower calendar, Wallflowers are listed under April and represent beauty, grace and enchantment.

E

Euphorbia Tirucalli
Pencil Cactus

Year Round

Euphorbia

Euphorbias is a large plant family that represents a wide spectrum of biodiversity.

Not a true cactus, Pencil Cactus is actually a Euphorbia closely related to Joe Pie Weed, Crown of Thorns and Devil's Backbone. A popular potted plant in Florida and Georgia, it makes a nice addition to any small garden. The Pencil Cactus has an upright, branching quality that lends itself to placement as a filler-plant for tight spaces.

The common name alludes to the shape of this Euphorbia's branches. The configuration resembles pencils stacked end-to-end. Easy to root and easy to grow, the Pencil Cactus is a good choice for beginning gardeners and school-age children. Able to withstand drought, the Pencil Cactus only requires a warm sunny location and organic fertilizer made for succulents. When outside, Pencil Cactus should only need rainwater.

Fun finger
Gardening can be magical.

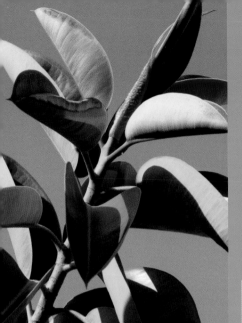

Ficus Elastica
Rubber Tree or Banyan

Evergreen

Ficus

The Rubber Plant is a regular in the Florida landscape, but can be seen growing in tropical regions around the world. The milky sap, when processed into latex, has proved to be an economic staple in tropical regions.

Ficus Elastica

The Ficus is a diverse family that includes Figs, Vines and house plants.

The Rubber Tree gets its common name from the sticky, milk-colored sap it produces. The sap is harvested and processed into a durable form of rubber for commercial applications. In its native southern Indonesia, rubber is used to seal canoes. In America, Rubber Tree plantations were utilized during World War Two to supply the military with rubber for tires. Many thought that Ficus rubber would continue to be a robust industry after the war, but manufacturing companies found that synthetic rubber was cheaper to produce.

With age, Ficus Elastica will grow root branches that dangle from the canopy and eventually root into the ground as a way to stabilize itself on sandy coastal ground. The Ficus Elastica can live for hundreds of years and is considered sacred among Buddhist burial sites in Cambodia and Laos. The majestic beauty of the Banyan Tree has inspired many poets and songwriters over the years. Paul Simon, of the singing group Simon & Garfunkel, mentions Banyan tree leaves in his song *Spirit Voices*, from the album *"The Rhythm of the Saints"* (Warner Bros. Records).

A grand evergreen tree for the Florida landscape, the Rubber Tree can be seen growing all over Miami and the Florida Keys. Although it resembles the Southern Magnolia, it is actually a member of the Fig family, Ficus. This tree, being a true Fig, will develop fruit under one condition: pollination by a Fig Wasp, the sole pollinator of the Rubber Tree.

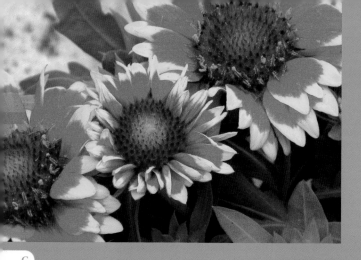

Gaillardia
Gaillardia
Gaillardia

Gaillardia is one of the most reliable flowering perennials for the often hot and dry southern garden. As many other perennials wither in the August heat and humidity, the Gaillardia remains turgid and brilliant.

Geranium
Cranesbill

Spring

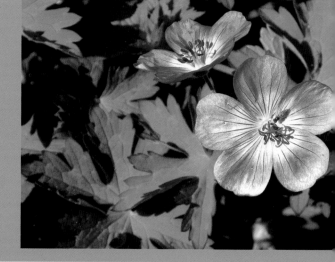

Geranium

Cranesbill is one of many flowering perennials in the Geranium family.

A favorite of fairies, the Cranesbill Geranium is a small flower native to Europe. Garden fairies have inhabited flowers in the English garden for centuries, while in France they visit only when the moon is full. In Greece, garden fairies are Nymphs and in Italy they are Fata. Wherever gardeners go in Europe, they will be surrounded by these keepers of the garden.

Because of their association with fairies, Cranesbill is a favorite plant with children. Its flower is easy to grow, bringing success and happiness to the beginning gardener who has a range of colors to choose from, including lavender, white and several shades of dark pink. A semi-shady spot and occasional waterings are the only requirements for the perennial Cranesbill Geranium to flourish. Its small, simple flowers will self-seed in the garden, but it is not invasive and new plants can easily be dug up and transplanted to a more suitable space.

Gomphrena or Gom-friendly

Spring to Summer, Annual

Gomphrena

A late summer annual for difficult conditions. The Gomphrena thrives in both the coastal and piedmont regions of North and South Carolina.

Gomphrena is a small, heat-tolerant garden annual in coastal areas. The stiff-textured flowers make excellent dried flowers, as they retain "everlasting" color after cutting. There are several varieties of Gomphrena, with colors ranging from bright fuchsia to white. The flowers of this upright plant attract butterflies to a summer border as they open in mid-July. As the summer wanes, the Gomphrena opens fully and the texture softens. It is a favorite in English gardens.

A halophyte, Gomphrena must be grown in coastal areas where there is high salt content, such as brackish water, so it will thrive on the ocean coast. Inland, Gomphrena is a short-lived annual that needs special care to survive, including the introduction of salt to the water source.

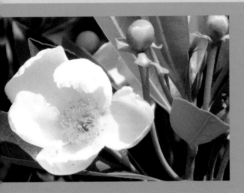

Loblolly Bay

Evergreen, Spring

Gordonia Lasianthus

Loblolly Bay, a native wild flowering shrub, has recently been introduced to the landscape trade. Its history in native American folklore is extensive.

A native of the east coast, from Virginia to Florida, the Loblolly Bay is a standard among flowering evergreen shrubs. It is an old fashioned and upright shrub, that has been utilized by landscapers for decades. Once found only in the wild, the Gordonia has increasingly come into garden-center stock in recent years. Its tall conical shape plays an important part in garden design plans, such as framing a patio or deck area.

Loblolly Bay is a member of the Theacea family of flowering plants, making it a close relative of the Tea Shrub (Camellia Sinensis), the common Camellia (Camellia Japonica) and Schima. While other members of the Tea family flower in a wide range of colors, the Loblolly Bay flowers are only white.

Hamelia Patens
Firebush

Evergreen, Spring to Summer

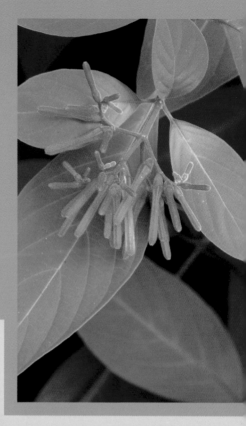

Hamelia

A truly tropical shrub that thrives in central and south Florida. In Georgia and north Florida the Firebush is a tender dieback perennial.

Firebush is native from central and south Florida into the Caribbean, where this flowering evergreen grows continuously. In north Florida, Firebush is a dieback perennial shrub. Its maximum size is three to six feet in height. Firebush is a wonderful choice for a butterfly or hummingbird garden. In south Florida it often is planted in wildlife gardens with other native shrubs, such as American Beauty berry (Callicarpa Americana) and Sweetshrub (Calycanthus). The flowers of the Firebush are red to yellow set on whirls at the tip of each branch. The berries are a favorite food source for birds.

Historically, people in tropical America have used extracts of the Hamelia leaves and stems to treat skin ailments, including rashes, sores and stings. Other traditional ethno-botanical uses include treatment for a wide range of ailments. Modern studies have shown that extracts of firebush contain antibacterial and antifungal properties.

In tropical American folklore, firebush is said to represent stories from Spanish conquistadors who introduced Catholicism to the New World. Already called Firebush when they arrived with the biblical story of Moses, the Spaniards used the Firebush to prove to the natives that their belief was true. Many natives heard the story of Moses and saw the Firebush, thereafter accepting Catholicism.

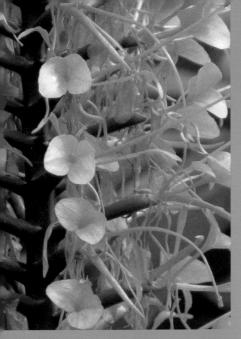

Hedychium
Coccineum

Bottlebrush Ginger

Spring to Fall

Hedychium Coccineum

A large, shade-loving Ginger.

Bottlebrush Ginger

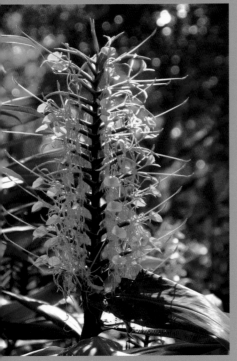

The Bottlebrush Ginger plant was named for its flower, which is shaped like an old- fashioned bottle brush. A true member of the Ginger family, it needs shade and regular amounts of water to stay turgid. Gardeners, from Titusville, Florida, to Wilmington, North Carolina, grow this Ginger with relative ease. Like all Gingers, the Bottlebrush is sensitive to frost but will almost always recover in the spring. This perennial is related to culinary ginger, but is grown by most coastal gardeners as an ornamental.

Native to southeastern Asia, Bottlebrush was brought first to Australia, then to Europe by traders in the South Pacific in the 1500s. Not well suited for most outside gardens in Europe, this Ginger was used as a houseplant and became strictly a plant for collectors. Spaniards brought it to Florida in the 1700s and it eventually made its way up the eastern seaboard.

Helianthus Debilis
Sbsp. Debilis
Beach Sunflower

Spring to Summer

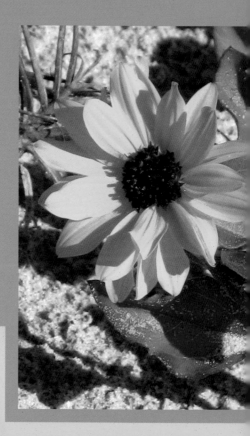

Helianthus

H

The Beach Sunflower was worshipped by Native Americans for its strong resemblance to the sun.

With a high tolerance for salt spray, salt water and full-sun, the Beach Sunflower is nearly a perfect beach-front landscape plant. The low-sprawling shape of the Beach Sunflower does not interfere with nearby Sea Oats or ocean views. It flows around and over dunes, from Florida to Virginia, providing erosion control and bright yellow flowers to coastal landscapes. While in cultivation, the Beach Sunflower spreads along the littoral zone as a wildflower.

Like all members of the Sunflower family, Beach Sunflowers strongly attract several varieties of birds, so wildlife observers at the beach can see flocks feeding on its small seeds. The best time for bird-watching around this spring flowering plant depends on its location and what other plants are available. The flowers last well into summer, with fall blossoms not uncommon.

Helianthus Debilis is a close relative of the regular, upright Sunflower (Helianthus Annus) that is familiar to gardeners across America. In ancient as well as recent times, the Sunflower has been associated with sun worship among some South American native tribes.

Helleborus
Lenten Rose or Christmas Rose

Evergreen, Spring to Summer

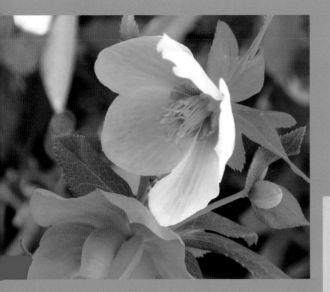

Helleborus Orientalis

The Christmas or Lenten Rose is so-named due to its late December flowering.

Practitioners of Black Magic are known to use Helleborus to summon evil spirits. Lenten Rose, commonly found in forest settings, are cut, dried and burned as a lure for demons. Hellebore smoke winds through the trees where rituals are conducted, attracting spirits with its strong scent. This practice is furthered by the deadly nature of the botanical name, a combination of the words "Hell" and "bore," to carry.

Greek legend relates that Hellebore was given to Alexander the Great as an herbal remedy for fever. Because Hellebore is poisonous, Alexander succumbed to the toxin. Who gave Hellebore to him and if they knew it was poison is lost in history.

For modern gardeners, Hellebore is most often called the Christmas Rose, due to its flowering around Christmas time in the winter. In recent years, it has become a favorite perennial in shady areas, for its spreading evergreen foliage can be prolific under ideal conditions. While lime treatments were recommended in the past, gardeners now realize that Lenten Rose grows quite well without supplemental fertilizers.

Hydrocotyle

Dollarweed or Pennywort

Evergreen

Hydrocotle

Dollarweed is one of the most invasive plants in coastal regions. Its presence is an indicator of an over watered lawn.

Dollarweed is a perennial that gets its common name from coin-shaped leaves. It has a low growing habit and spreads by seeds, tubers or rhizomes. The leaves are round, bright green, fleshy and resemble lily pads. A single Dollarweed patch can contain hundreds of leaves that are from one to three inches across. A scalloped margin defines the edge.

Also called Pennywort, most coastal gardeners consider it aggressive and invasive. The botanical name, Hydrocotyle, means "water womb." Its presence is an indication of high water content from over-irrigation in the ambient soil. Reducing the running time on an irrigation system can help control Pennywort and save water and money. Irrigation systems should be run for only 20 minutes or less, twice a week, between 7:00 and 11:00 in the morning. Most qualified landscapers believe the coastal gardener needs to run an irrigation system only in July and August.

Ilex Rotunda
Lord's Holly

Evergreen

Ilex Rotunda

The Holly is sacred to both Christians and Pagans.

Lord's Holly has an overhead display of glossy leaves and small, red berries that can reach thirty or more feet across, in a majestic umbrella-shaped canopy. The leaves have a deep shade underneath. While the leaves and berries tell gardeners that it is a Holly, the massive, sculptural trunk fascinates most people. The Lord's Holly starts out as a small tangled shrub but develops into a masterpiece of branches as it ages.

Low-growing branches are thick and stable, spreading out just above the ground, providing children with a fun place to climb and play on a warm summer day.

Ilex Vomitoria
Pendula

Weeping Youpon Holly

Evergreen

Ilex Vomitoria Pendula

Bright red berries in early winter attract birds to the Weeping Holly.

The Weeping Holly is one of the most reliable trees for the coastal landscape.

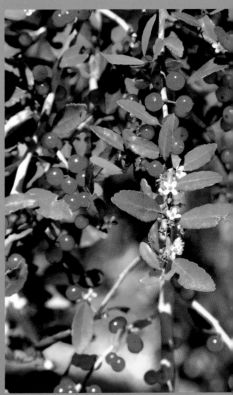

Ilex Vomitoria Pendula is a regular evergreen shrub that grows from north Florida into Virginia. Ilex is the botanical name for Holly. Vomitoria refers to the berry that Native Americans used to take to force vomiting as a form of stomach ache relief, and Pendula is the Latin word for pendulous, or dangling.

There are two main types of Hollies, Crenata and Cornuta. The Weeping Youpon Holly is a Crenata, meaning it has small leaves. The Cornutas have large leaves. Holly enthusiasts can remember the two with an easy trick: Crenatas are native to Japan, a small Island, and Cornutas are native to China, a large country. Unlike some exotic plants, Hollies are not invasive and will not take over the landscape. Hollies like full sun, and somewhat dry conditions, and they are generally tolerant of salt spray and brackish water. The sterile berries, bright red and profuse, do not attract the attention of birds.

The Weeping Youpon Holly is a large, upright and weeping version of a standard Youpon Holly, which is a tight, compact, hedge shrub. The mature Weeping Youpon Holly stands about fifteen feet tall and is one of the easiest plants to care for in a coastal garden.

Indigofera

Indigofera or Indigo

Spring to Summer

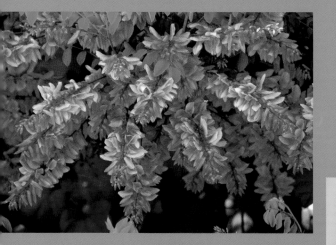

Indigofera

The dye made from Indigo is a rich blue color.

Indigofera is a truly cosmopolitan plant with worldwide distribution; colonies can be seen in the Americas, Europe, Asia and Australia. While the Indigofera plant has long historical roots in Ethno-botany, its ornamental use among modern gardeners today guarantees its status into the future.

Indigofera is the original plant source for Indigo dye. Suffruticosa and Tinctoria are the two varieties of Indigofera that are harvested for Indigo production. This dye produces a deep, rich, blue color that is close to violet on the color wheel.

Prior to the American Revolutionary War, Caribbean growers brought Indigo to the colony of South Carolina, where Charleston, an established port city, became the primary place for Indigo production. In 1739, at the age of 16, Eliza Lucas Pinckney began to oversee three family-owned plantations near Charleston. Along with slaves from the West Indies who had prior knowledge of Indigo production, Pinckney developed a method for setting the Indigo dye so that it did not bleed or wash out of fabric. This development, along with ther seed production, made Indigofera an economically viable crop in a competitive market. By the late 1740s, Indigo accounted for a third of all exports from Charleston. Rice was the only production crop with more export value. Eliza Pinckney kept a letter journal that traced her methods, and these became the first production and business plans written by an American woman.

Charleston was not the only place to use Indigo as a dye. In Senegal and Singapore, Indigo dye has historically been used in the making of a cloth known as Batik. The term "Batik" today can refer to a cloth with a Batik design, or to the design itself. In Indonesia, Batik designs, created with Indigo dye, can have spiritual and cultural meaning, including representing the three major Hindu gods: Brahma, Vishnu and Siva.

Sweet Potato or Morning Glory

Spring to Summer

Ipomoea

Sweet Potato Vine is easy to grow and comes in three colors.

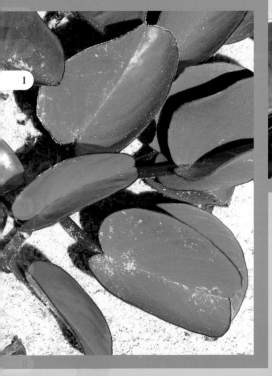

The Sweet Potato's origin poses a great question, because it is the only Polynesian-introduced plant that does not originate in Southeast Asia. In fact, it came from the opposite side of the Pacific Ocean in South America. There are several competing theories about the Sweet Potato's arrival in Polynesia: 1) that 'uala floated to Hawai'i on a log, 2) that a Polynesian person sailed to South America and came back with the 'uala, or 3) that South American Indians sailed into the Pacific, taking the 'uala with them.

However it arrived in Hawai'i, the Sweet Potato gained a strong importance there. The semi-desert & desert habitats of leeward mountain slopes above the littoral zone were too dry to support large populations of Taro, which required additional water. The Sweet Potato, however, thrived in the arid conditions and enabled Hawaiians to increase the size of their dry-land settlements. The Sweet Potato became an embodiment of Lono, the god of rain and agriculture, among other things.

Over fifty varieties of Hawaiian Sweet Potato can be grown in tropical areas of Florida, and several types can be grown in the Carolinas.

Itea Virginica
Virginia Sweetspire

Year Round

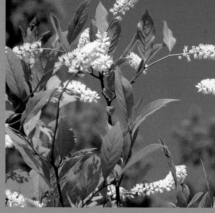

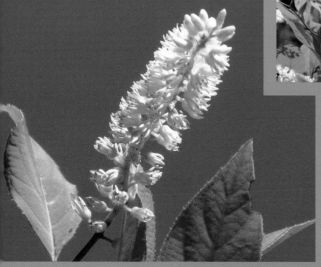

Itea

The Virginia Sweetspire provides coastal gardeners with beautiful springtime flowers and stunning fall color.

In American folklore, Virginia Sweetspire is associated with magic and spirits.

An old fashioned shrub, the Virginia Sweetspire has been delighting gardeners year-round for generations. A Virginia native, the Virginia Sweetspire was named for its spire-shaped, flower inflorescence that emits a sweet but low-key scent. There are several varieties of Itea whose overall shape can vary from species to species. Some Iteas are tall and upright, while other varieties are small and weeping. Some varieties of Itea remain in clump form, while others spread out, forming colonies that can eventually fill a small space.

In the spring, the Virginia Sweetspire has an abundance of scented white flowers that emerge from the ends of the branches, while the new spring leaves are lime green. Over the summer the Virginia Sweetspire grows rapidly, developing large leaves and a multi-trunk form. As winter approaches, the Itea shows off a wildly motley display of fall color. Deep burgundy, red, yellow, lime and orange are just a few of the colors displayed for weeks, from October to November. Even in the dead of winter, the Virginia Sweetspire has an interestingly textured, exfoliating bark to show-off along its branches.

The Virginia Sweetspire was traditionally planted in the gardens of many American colonial homes. Several old-growth specimens can be seen in Washington, District of Columbia, and on the many historically significant plantations and estates along the east coast of Virginia. Williamsburg, Virginia, displays some of the oldest Sweetspires in America. The Virginia Sweetspire can also be seen in abundance on the western shores of the Albemarle Sound and south to New Bern, North Carolina.

Jacksonville Beach Front

Landscape plantings along Jacksonville Beach.

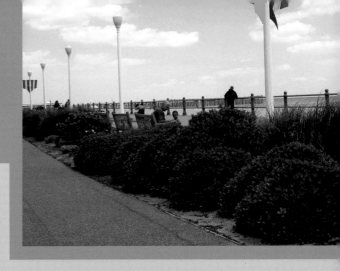

Juniperis Conferta

Emerald Sea Shore Juniper

Evergreen

Juniperis Conferta

Sea Shore Juniper thrives in the hot, dry and salty conditions of the coast.

Coastal gardeners know that conditions on the beach can be harsh, and plants there need to withstand constant wind, salt water and fluctuating temperatures. Rightly named, Emerald Sea Shore Juniper preforms well in beach and coastal conditions. This low-growing Juniper is a perfect ground cover for coastal areas, with its high salt tolerance and ability to stand full sun. The Emerald Sea Shore Juniper forms thick mats of densely tangled branches that have hundreds of short, stiff leaves in a beautiful whirled arrangement. The leaves of the Emerald Sea Shore Juniper are aromatic and blend well with Gardenias in the coastal border. A showstopper in a raised bed, the Juniper sends branches flowing out of the main clump and sprawling over the sides, adding elegance to the beachfront garden. The Juniper shown here was photographed on Tybee Island, Georgia.

While appreciated for their ornamental value, as a dune plant Juniper becomes invaluable to beach-front communities; they are widely planted for dune-erosion control. Their thick mats and extensive root systems help to stabilize dunes and secure sandy areas, while maintaining a natural look.

Juniperis Virginiana
Eastern Red Cedar

Evergreen

Juniperis Virginiana

Eastern Red Cedar is a North American native tree.

Eastern Red Cedar

"...about eight in the morning I first set foot on American ground. It was a small uninhabited island...over against Tybee, called by the English Peeper Island. Mr. Oglethorpe led us through the Moorish land on the shore to a rising ground,...we chose an open place surrounded with myrtles, bays, and cedars, which sheltered us from the sun and wind, and called our little flock together to prayers."

The preceding text is a passage from the 1736 journals of John Wesley, and is inscribed on the Wesley monument at Fort Pulaski State Park near Tybee Island, Georgia. The Cedar mentioned by John Wesley, later the founder of the Methodist religious denomination, is most likely the Eastern Red Cedar, which is ubiquitous along the southern East Coast. The Myrtle mentioned is the

Juniperis Virginiana Eastern Red Cedar

Wax Myrtle (Myrica Cerifera) and the Bay mentioned is the Loblolly Bay (Gordonia). These three plants are all natives of the eastern United States.

The Eastern Red Cedar can be seen along fences and across neglected fields all over eastern America. Its strong, upright form Eastern makes Red Cedar a familiar landmark from Kentucky to Florida. Rarely planted by humans, the majority of specimens are wild, deposited by bird droppings. Despite the name Cedar, this tree is not a true Cedar at all, but a type of Juniper.

Until the advent of modern Christmas tree farms, Christians used readily available Eastern Red Cedar as their Christmas Trees. Because it is an evergreen and teardrop shaped, many Americans still follow the tradition and prefer Eastern Red Cedar as their Christmas tree. It provides strongly scented, green foliage and stout branches for use in garlands and wreaths.

Historically, the seed cone (sometimes inaccurately called a berry) of Eastern Red Cedar has been used to produce "Juniper Gin," a fermented alcoholic beverage that was made by early American colonists along the east coast.

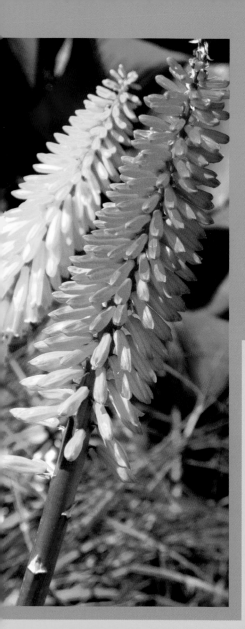

Kniphofia

Red Hot Poker or Flame Lily

Spring

Kniphofia

Red Hot Poker is perfect for hot dry conditions.

The Red Hot Poker is unique among coastal garden plants; it's common name derives from the shape of its inflorescence that resembles a fire poker. The leaves are three-sided and arch outward in a rosette pattern. Many small red-to-orange flowers cluster at the top of the stem to develop a uniform color scheme. The majority of coastal gardens are very humid, and the Red Hot Poker thrives in that humidity; but it also is capable of thriving in the southwest desert, where there is virtually no humidity and drastically different soil conditions.

Kolkwitzia Amabilis
Beauty Bush

Spring

Kolkwitzia Amabilis

Beauty Bush is native to central China.

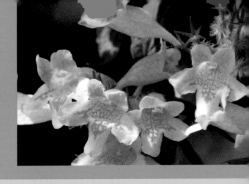

The genus Kolkwitzia is named for German Botanist and inventor Richard Kolkwitz, who lived in the late nineteenth and early twentieth centuries.

An old-fashioned garden shrub, the Beauty Bush is grown for its large, arching and graceful shape and the abundance of white-to-pink flowers in the early summer. Its bark cracks and exfoliates in strips, adding to its winter attraction. Beauty Bush has a sweet scent that reminds gardeners that it is related to Honeysuckle.

The Beauty Bush was historically used as a landscape shrub and can be seen in royal gardens and at estate homes throughout Europe.

The Kolkwitzia's beauty was highly desired in ancient Europe. A story from France tells of a woman who traded her large home for one plant. When her husband returned from his travels and found his house gone, and only a Beauty Bush in his garden, he could not be angry at his wife for having made the trade, but simply planted her body under the Beauty Bush so that she could continue to feed and enjoy the shrub. The next winter, he pulled its branches over himself as protection from cold winds and shriveled in stature. He is said to still live today in the form of a garden elf.

Lathyrus Latifolius
Sweet Pea Vine or Everlasting Pea Vine

Summer Annual

Lathyrus Latifolius

Sweet Pea is beautiful, but can be invasive.

Sweet Pea Vine can be seen growing wild across coastal areas in the east and Gulf coasts. Many gardeners consider this scandent flowering vine an invasive nuisance, while still extoling its beauty. It grows rapidly over the summer months, splashing small pink flowers over fences, shrubs and trees, while producing pea-like pods.

Flowers of the Sweet Pea Vine are pollinated exclusively by bumblebees, and several varieties of butterflies are known to visit them.

Leptospermum Scoparium

New Zealand Tea Tree

Summer to Fall

Leptospermum Scoparium

The Tea Tree is related to the common Myrtle.

New Zealand Tea Tree

A legend from the South Pacific relates that New Zealand Tea Trees are inhabited by good spirits who watch over the fields and livestock to protect them from evil spirits who roam the countryside. Each time a good spirit drives off the will of an evil spirit, a new flower emerges. Therefore, a homeowner wants tea tree flowers to appear when their property is for sale.

The small flowers are borne on scraggly plants that resemble the Rosemary shrub. Several types of bees gather nectar from the flowers of New Zealand Tea Trees, and this nectar is processed into a Leptospermum honey, which used by natives of Australia and the New Zealand Islands. Traditionally, leaves of this Tea Tree have been brewed as an herbal drink, not a true tea but one that relieves muscle pain and ease anxiety. True teas are made from the leaves of Camellia Sinensis.

Leucanthemum
Shasta Daisy

Spring to Summer

Leucanthemum

Leucanthemum is a white variety of Sunflower.

A classic, old-fashioned garden flower, the Shasta Daisy lights up a sunny border with profuse, bright-white petals set on tall, turgid stems. The Shasta Daisy is a colony-forming perennial that has become an American favorite. The spring flowers greet daylilies and Fish Mint, as they all flower together. White flowers are historically associated with purity, hope and innocence.

Shasta Daisies were once classified as Chrysanthemums, but are now in their own family, Leucanthemum. Among the easiest plants for beginning gardeners to grow, they require no care beyond occasional watering the first season after planting and they need to be cut back in the early winter, to maintain a neat appearance in the garden.

Lewis Ginter Botanical Garden

Ligustrum
Privet

Evergreen, Spring

Ligustrum Ligustrum is also known as Privet.

Privet is a hardy shrub from Florida to Maine, known to gardeners in the south as a large waxy-leaved evergreen, while in the north it is recognized by small, matte leaves. Privet is widely planted around coastal Georgia and the Carolinas as a buffer shrub, providing dense obstruction of unwelcome views. A completely carefree shrub once established, Privet can be left to sprawl or be trimmed into neat hedge rows. A wild variety of Privet grows in undisturbed areas of the east coast, but many landscapers consider this Privet to be invasive.

Native to Europe, Privet is associated with spirits that protect trees from anything that might want to harm them; therefore, its flowers are aligned with protection and goodness.

Gardeners with asthma need to be aware that, in the springtime, Privet's tiny white, pollen-producing flowers can aggravate their condition.

Lithodora or Blue Eyes Upward

Lithodora Diffusa

Spring

Lithodora

Lithodora is a fleshy groundcover that flourishes in full sun.

Small Blue flowers spangle a matte green field.

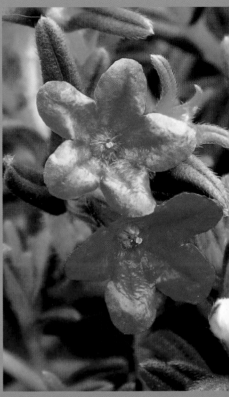

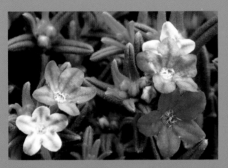

Bright blue flowers, dark green Rosemary-like foliage, and a ground-hugging habit make Lithodora a useful plant for a sunny landscape. Along with Ajuga, Verbena and Vinca, it is one of the best blue-flowering ground covers. Because blue is one of the rarest colors for flowers, Lithodora is gaining popularity among gardeners wishing to expand their palette. The small flowers begin to emerge in March and continue to flower regularly until mid-autumn in the states of Georgia, South Carolina and North Carolina.

Once known as Lithospermum Diffusum, today most gardeners know this plant as Lithodora Diffusa. It requires only minimal care beyond a full-sun location that is dry. Blue Eyes Upward needs an organic, acid-based fertilizer and will perform best at the inland edge of this book's range, about twenty miles from the coast. In time, the center of the plant will die out as this ground cover spreads outward. A simple trimming every couple of years will help to keep Blue Eyes Upward looking fresh and flirty. Rosemary, Yarrow, Sedums and Roses make outstanding companion plants for Blue Eyes Upward. For coastal gardeners with limited space, the Lithodora makes an excellent hanging basket plant, on a south- or west-facing porch.

In folklore, Lithodora was known for its ability to lift a person out of a state of melancholy. Upon seeing these blue flowers, one would be left with joy, hence the common name, Blue Eyes Upward, describes the uplifting of spirits.

Cardinal Flower

Spring to Summer

Lobelia

A native wildflower, Lobelia is cherished by American gardeners.

Cardinal Flower

A small, native wildflower, the Lobelia is noted for its bright red, Cardinal-like color and ability to draw hummingbirds to the garden. Noted for their copious amounts of nectar, Lobelias provide hummingbirds with food throughout the season. Bees and butterflies are also strongly attracted to the Cardinal Flower.

Not a fussy perennial in the southern garden, it can withstand hot, dry locations as well as shade. The Lobelia blossoms in the spring and produces stunning color until the fall.

The Cardinal Flower is sacred in the Roman Catholic religious tradition and is often planted outside Cathedrals. The common name, Cardinal, recalls their revered leaders, while the bright red color is a symbol for the blood of Christ. Lobelia is sometimes grown alongside the Elegant Ruellia (Ruellia), another plant that is known in Catholic tradition.

Lobularia Maritima

Alyssum or Sweet Alyssum

Summer, Annual

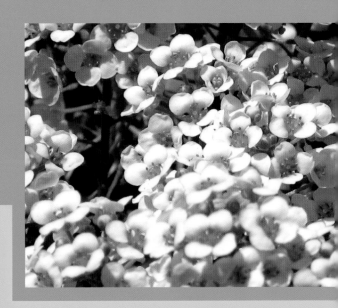

Lobularia

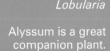
Alyssum is a great companion plant.

This small, delicate flower is often used in America for container gardening. Its loose flower clusters flow in billowy clouds over the sides of decorative pots, adding texture and brightness to a patio or porch. Alyssum needs to be watered often and protected from full summer conditions. Sweet Alyssum is an easy-to-care-for annual, making it a fine bedding plant for summer vacation homes and children's gardens.

The Alyssum was recently re-assigned to the genus Lobularia and it is a member of the Mustard family, as its tiny seeds suggest. All members of the Mustard family are native to the Mediterranean region and have been cultivated since ancient times. Mustard seeds are popular in the Middle East today for culinary use and as a yellow dye for fabrics.

Cruciferae, another accepted name for this family of flowering plants, means "cross bearing" and refers to the four petals that make a cross on Alyssums. Alyssum is pure white, a sacred color for Christians. Therefore, members of the Christian tradition have planted this flower in memorial gardens for generations.

In the language of flowers, Sweet Alyssum is said to represent purity, hope and favor. According to a legend, the name Alyssum is derived from a young girl by that name who grew it in her garden, with the hope that angels would come to visit. When they did come, they loved the flower so much that they took it to gardens all over the world. Therefore, any garden with Alyssum growing in it is watched over by angels.

Lobularia

White or Lavender specimens of Alyssum are available.

Loropetalum or Hazel

Year Round

Loropetalum

A sandpaper like texture covers the Loropetalum's leaves.

Hot pink flowers can cover the Fringe Shrub at any time of year.

L

Legend tells the story of Hazel's use by the Native American tribe Menominee, from Wisconsin. They boiled the leaves of the shrub and rubbed the liquid on their tribesmen's muscles, which were sore from long hunts or vigorous games.

A folklore story, from the Native American Potawatomi tribe, tells of the healing spirit of Hazel. A Hazel branch is burned and the smoke is used to call the healing spirits, who ride down through the smoke into the branch. Whoever holds the burning branch receives the healing power from the spirits. Legend says this is where the idea of funeral incense comes from: the swirls of incense smoke beckon the healing spirits, who may bring the dead back to life or comfort to the mourners.

Reminders of this tale remain today in the hot pink flowers that emerge, like flames of fire, from the tips of the Hazel plant.

Magnolia Liliiflora
Purple Magnolia or Tulip Magnolia

Spring

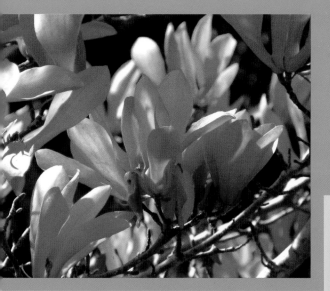

Magnolia Liliiflora

Magnolia is a classic garden flower.

A harbinger of spring, the Tulip Magnolia has one of the first flowers to emerge when the weather warms up. A native of China, the Magnolia Liliiflora has been cultivated throughout Asia and Japan for centuries. It was introduced to Europe in the 1500s and is widespread on that continent.

The name Magnolia comes from the word *Magnoliophyta*, the botanical name for every flowering plant. A cosmopolitan family, the Magnolia group is ancient and botanists are not sure on which continent they first grew. The common name, Tulip Magnolia, comes from the flower's resemblance to a Tulip.

Large upright purple-to-magenta flowers develop on leafless branch tips in February or March, depending on location. Over the course of the summer, the Tulip Magnolia provides shade with large leaves held on densely arranged branches that can reach fifteen feet or more in height.

The Magnolia family is quite large, with many different shapes and attributes. Unlike familiar Southern Magnolia, the Tulip Magnolia is deciduous, so it drops its leaves in the winter.

Pagan legend relates that a mysterious wizard is coming to visit when the flowers of the Magnolia blossom. The wizard, called "Magnificent," emerges from Tulip Magnolia flowers as they open in the spring, and leaves his magenta-colored presence on the petals. Whosoever has a Tulip Magnolia will be blessed with amazing gifts from the wizard of healing and enlightenment; whosoever does not grow the Tulip Magnolia will be left without the "Magnificent" wizard's gifts.

Mandevilla

Mandevilla

Spring to Summer,
Annual

Mandavilla

A stunning tropical
vine for mailboxes
and fences.

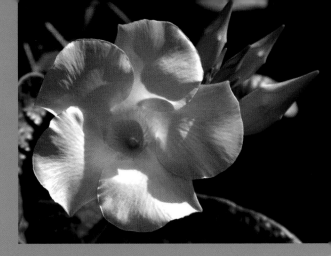

The Mandevilla is a tropical vine that is most often used as a container plant to grace porches and patios. An annual north of central Florida, Mandevilla has one of the most recognizable flowers in the spring and summer display. Trumpet shaped and usually light pink in color, the Mandevilla flower is known for its unusual way of unfurling; it opens while twisting, similar to the rotation one might see on a ceiling fan.

The flowers are borne on twining scandent vines that also hold its large leaves. Mandevilla is fussy and can be pestered by spider mites and powdery mildew, therefore some maintenance is required.

Melissa Officinalis

Lemon Balm

Year Round

Melissa

Lemon Balm is a
traditional herb
steeped in history.

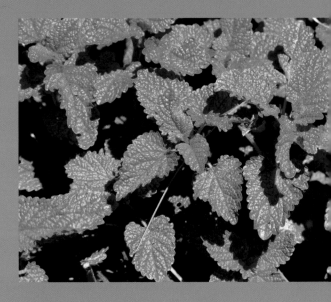

Melissa

Lemon Balm thrives in full sun.

Lemon Balm is a low-growing herb that forms mounded mats in the coastal garden. The textured leaves produce a fragrant lemon scent when scratched; they also have a distinctive lemon taste. The flowers, which blossom from June to October, are white to yellow in color. Lemon Balm will die down in the winter, but is a perennial and will return with vigor in the spring.

The genus Melissa is widely distributed throughout Europe, Asia and North America. The name Melissa is from the Greek word meaning "Honeybee." The flowers produce copious nectar that attracts bees, leading to the Genus name. Lemon Balm is well known to beekeepers who regard it as essential near a beehive to keep a hive together.

Pliny the Elder, a Roman naturalist and philosopher, said of Balm in 63 B.C.E., "It is of so great a virtue that, though it be but tied to his sword that hath given the wound, it stauncheth the blood." Pliny implied that it could stop blood flow from a sword wound. The blood-clotting factors of Balm have been referenced in folk medicine journals.

More than five hundred years after Pliny wrote about Melissa, botanists throughout Europe were growing it. Paracelsus, a Swiss alchemist, botanist and scientist, noted it highly, commenting that Melissa could revive a man in a state of nervousness. In 1536, he wrote that Melissa was of importance in the treatment of all complaints that stemmed from the nervous system.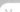

In 1696, an article in the *London Dispensary* mentioned Melissa as part of a tonic: "An essence of Balm, given in Canary wine, every morning will renew youth, strengthen the brain, relieve aches and prevent baldness." Scientists of the time deemed Lemon Balm useful against nervous headache and other afflictions. Lemon Balm appears in many folk remedies today, often being steeped as an herbal brew.

Lemon Balm also has long been associated with Paganism and been used in earth-based religious services as an herb with powers of serenity, bringing rest to the user. When soaked in hot water, Lemon Balm steam acts as incense, and when inhaled seems to achieve a trance-like state in which to perform acts of healing.

Sunshine Mimosa or Pink Powderpuff or Sensitive Plant

Spring

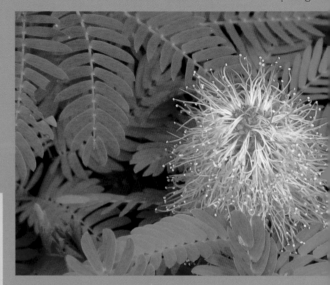

Mimosa Strigillosa

Mimosa Strigillosa is a native groundcover.

A groundcover, the Mimosa Strigillosa is a native southeastern and southwestern perennial. The Sunshine Mimosa forms thick mats and is very tolerant of dry conditions and full sun. Like most members of the Legume family, it fixes Nitrogen at the root level and therefore doesn't need fertilizer.

Xeriscaping landscapers, as well as natural gardeners, have started to install and recommend the Sunshine Mimosa. The plant is also recommended as a lawn grass replacement because of its ability to withstand some foot traffic as well as mowing. It is capable of spreading several square feet in a growing season, but is rarely considered invasive. This perennial is not, despite its name, related to the Mimosa Tree (Albizia Julibrissin). The Sunshine Mimosa is sometimes called the Sensitive Plant due to its habit of closing its leaves when brushed. The other common name, Pink Powderpuff, is a reference to the pink flower.

Butterfly enthusiasts have discovered that the Sunshine Mimosa attracts Little Sulfur butterflies, as well as several other beneficial critters.

Because of Sunshine Mimosas many positive attributes as a groundcover landscaping plant, it was named one of the plants of the year for 2008. It has gone on to be featured in several prominent gardening magazines and television shows, with all of them extoling its virtues.

Muhlenbergia
Sweet Grass

Fall

Muhlenbergia

Sweetgrass

Sweetgrass baskets are a tradition in coastal South Carolina.

In South Carolina, Sweet Grass is more than just an ornamental grass grown for its feathery purple plumes; it is a cultural icon. Sweet Grass is the grass traditionally grown by African Americans of West African decent to make the historically significant *Sweet Grass Baskets* that are as much a part of South Carolina heritage as *Carolina Gold* Rice. Museum quality *Sweet Grass Baskets* are to this day handmade, mostly by women of Gullah heritage, and sold in the market areas of Charleston. The *Sweet Grass Basket* craft is passed down from mother to daughter, creating a basket weaving family tradition. Originally produced for utilitarian purposes, the many different designs, shapes and sizes served a variety of needs. Most *Sweet Grass Baskets* are made today for the tourist industry, but are of heirloom quality.

Muhlenbergia, nicknamed Sweet Grass because of its sweet scent when first harvested, can be grown in any regular garden soil with little care. Its rosette of stems holds soft plumes that appear in the fall. The Muhlenbergia is a tough perennial grass that is used throughout the Carolinas as a median planting. Like other ornamental grasses, Sweet Grass needs to be cut down entirely each year in early winter so that the new leaves can emerge in the spring. Sweet Grass needs to be watered sparingly in the winter months and generously during the heat of the summer.

Nepeta Ssp.
Catmint or Catnip

Spring to Summer

Nepeta

Catnip

A full-sun, perennial herb, Catnip has a robust scent that is irresistible to cats. For about two thirds of cats, this plant has an enchanting effect that induces bouts of euphoric playfulness, a feline will mirthfully roll and stretch while appearing a bit loopy for an average time of thirty minutes. Big cats, such as lions and tigers, are also susceptible to the effects of Catnip and can become frolicsome under its spell.

A member of the Mint family, Catnip has been used historically as a mild sedative for humans. Steeped as an herbal brew and taken in small doses, Catmint has been known to calm anxious nerves.

Catnip has upright stems that are square, a trait of the Mint family. A grass-blade plant sold in pet stores as Catnip is false labeling;

Catmint leaves are not blade-like; they develop on stems and have petioles. The leaves of the Nepeta are opposite, simple, flat, and textured with serrated margins. Catmint is a close relative of Verbena, and the leaves and stems look similar.

Nepeta is easy to grow in the southern garden, with a range from Florida to Virginia and westward to Texas. Nepeta is native to most of Asia, Europe and parts of Africa. Catnip's small flower cluster, borne at the tips of its stems, are pink-to-purple and bear the dark speckles characteristic of the Mint family.

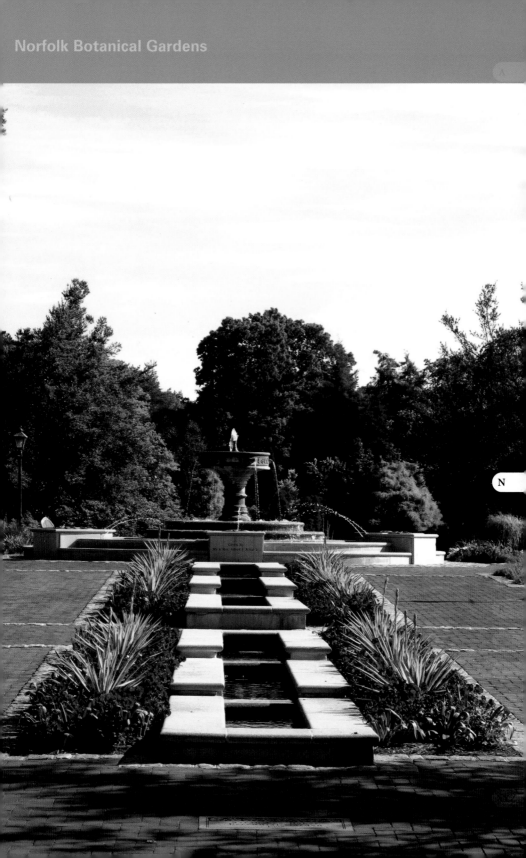

Nymphaea
Hardy Waterlily

Summer

Nymphaea

Hardy Water Lilies
have worldwide
distribution.

The word "Nymph" means "fairy" in Greek, and the Waterlily is a traditional place for fairies to sit and watchover the world. Many associations have been made between the Waterlily and fairies of the forest. Mythology relates that the dragonfly is a manifestation of a fairy that visits ponds, swamps and marshes where Waterlilies thrives.

Many gardeners install water gardens featuring Waterlilies. The wide, flat leaves float on the surface of the water and draw dragonflies and frogs to it. Hardy Waterlilies come in a wide range of colors including pink, red and white. In the south, Hardy Waterlilies are perennial plants that spend the winter in the water and return the next spring.

Odontonema Strictum
Firespike

Spring to Summer

Odontonema

A tropical, the Firespike grows best in warm humid gardens.

Firespike is a close relative of Acanthus, an historical plant in Greek tradition and is related to Mint, Rosemary, Snapdragons, Basil, Lilac, Lavender and Ash trees.

Firespike's common name derives from its inflorescence. The flower is a bright red spike that resembles Lobelia. Usully the spike is uniform; occasionally it mutates to great effect forming strange, sculptural displays above large tropical leaves.

Opuntia
Prickly Pear Cactus

Evergreen, Spring

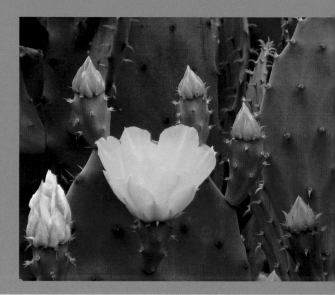

Opuntia

The flower of the Prickly Pear Cactus is edible.

One of the most hardy Cacti in the world, Prickly Pear Cactus flourishes in the wild and in the garden. The large pads grow in an alternate pattern supporting short thorns by the hundreds. As the Prickly Pear ages, the lower pads become woody, forming something resembling a trunk; some varieties they develop as ground-covers. The pads may be broken or cut-off at any time of the year and planted directly in the ground to produce new plants. In the eastern United States, the Prickly Pear develops large, bright-yellow flowers in the spring.

Prickly Pear's common name derived from the unopened flower head, called a Pear, that is eaten as a vegetable in parts of Africa and the Middle East, however the Opuntia is not a Pear (Pyrus). The pad is de-thorned and eaten as a regular part of the Mexican diet.

Orchid-CW
Orchid

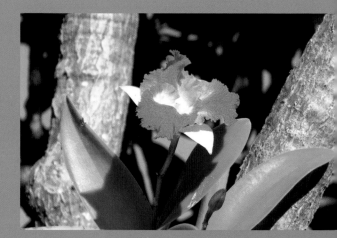

Orchid - CW

Orchid- Photo by Christine Winestein

Ornithogalum
False Onion, Pregnant Onion or Star of Bethlehem

Spring to Summer

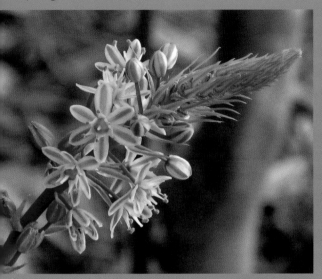

Ornithogalum

Star of Bethlehem was known to colonial gardener's as early as 1627.

False Onion is correctly called "false," because it is actually a Hyacinth. A bulbous flowering lily, False Onion is easy to grow and will produce many offsets that can be detached and used to start new plants. Therefore, False Onion is popular at many plant swaps in the spring and fall. Ornithogalum is sometimes called Pregnant Onion, alluding to its rounded, swollen shape. Collectors need to be aware that some varieties of False Onion are poisonous if ingested.

Another common name for Ornithogalum is Star of Bethlehem, so named for the shining white, star-shaped flower at the end of a long, arching stem. During the Christmas season, Star of Bethlehem can be grown in pots behind a nativity group, the bright flower acting as a living star reenacting the birth of Jesus.

Star of Bethlehem makes a reliable houseplant for container gardeners and is a perennial garden plant.

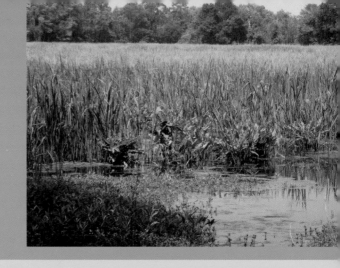

Oryza Sativa

Rice

Summer to Fall

Oryza Sativa

Rice field in the South Carolina Lowcountry.

Rice cultivation originated in the Yangtze River Valley of China thousands of years ago. Now cultivated all over the world, its primary production occurs in Southeast Asia and parts of Africa. Rice is second only to Corn in volume produced and it constitutes a basic food crop for over two thirds of the world's population. The Poaceae family, of which Rice is a member, also includes Bamboo, Barley, Corn, Grasses, Palm Trees, Reeds, Rye, Sugarcane and Wheat.

Rice in colonial times was first grown in North Carolina, South Carolina and Georgia and continued to grow in South Carolina until the end of the Civil War. Charleston, South Carolina, was America's fifth largest city until the 1840s and served as the center of American Rice production. Slaves from Madagascar who had previous knowledge of Rice culture were brought onto plantations around Charleston; because of their expertise, they were valuable workers.

Coastal South Carolina, often called "The Lowcountry", has bogs, marshes and wetlands that provided perfect conditions for Rice to grow. Rice cultivation needs highly controlled flooding and draining of the fields for success. "Carolina Gold" was a long-grain Rice and the standard in the lowcountry. It was hand harvested and loaded onto barges to be taken to the processing area of the plantation where it went through a threshing stage that removed the grain from the stalk. Rice at this level of production could be sold as "Rough Rice," but it was often processed further for sale as food stock.

Rice production was so important to the economic development of Charleston that in 1691, the South Carolina General Assembly changed its laws so that bills could be paid in Rice. By 1700, Charleston exported 335 tons of Rice a year to England. The Rice industry in Charleston declined after the Civil War when freed slaves went elsewhere for better pay and working conditions, leaving plantation owners with no source of labor.

The wealth that Rice brought to Charleston helped build the magnificent antebellum homes in the heart of the city. Today, several Rice varieties, including *"Carolina Gold,"* are produced in Charleston in small quantity, mostly for sale in tourist shops and for those studying the Ethnobotanical history of South Carolina.

Osteomeles Schwerinae
Summer Star

Spring to Summer

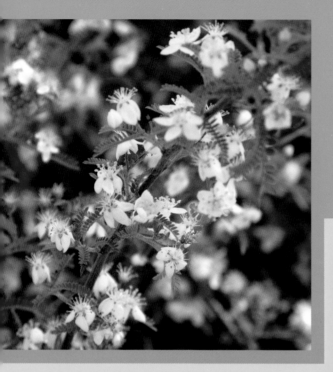

Osteomeles Schwerinae

White flowers and Mimosa like leaves cover the Osteomeles.

Osteomeles Schwerinae, a native of China, has white flowers that resemble those of the Hawthorn. The three-inch flowers are noted for their veining, in an opposing color inside bell-shaped petals. The Summer Star begins to blossom in April and flowers well into the summer.

The Summer Star shrub produces small, white berries that are Pomes, fruit with an interior seed and fleshy outside. The fruits are sweet and edible raw off the shrub, used to make jellies and jams. The leaves are strongly reminiscent of the Albizia.

This medium-sized, gracefully arching shrub makes a white display in the landscape. It is relatively unknown to most American gardeners, but it shouldn't be. Like many other plants from China, it is also used in the arbor art of Bonsai.

Passion Vine or Red Passion Vine

Spring to Fall

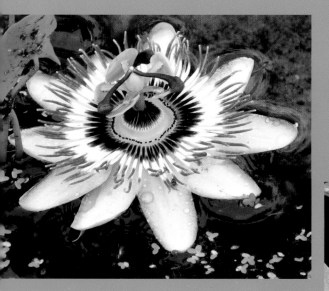

Passiflora

Widespread in seaside areas, Passion Vine flowers all season.

Passion Vine is an East Coast native.

Red is a color of passion, both in anger and in love, and the Red Passion Vine is associated with both forms. It is a vine that sprawls unattended across fences and trees throughout the southern states. Its bright red flowers emerge in the spring on scandent evergreen stems that hold large leaves and attract bees, butterflies and gardeners.

The Red Passion Vine is revered in the Christian religion for its color of blood and its tri-shaped stamen set that is said to represent the trinity. Pagans have long used the

Red Passion Vine in rituals, as the flower represents the blood of life and sacrifice. To them, the vine completes the cycle of life with those who have passed-on. There are also purple and white varieties of Passion Vine.

97

Peniocereus
Serpentinus

Serpent Cactus or Snake Cactus

Evergreen

Peniocereus serpentinus

A rare cactus that resembles a serpent.

Serpent Cactus

The long, slim, snake-like shape of Serpent Cactus develops limbs that recall Medusa, the mythological Greek gorgon.

A relative of the Night Blooming Cereus, it flowers at night, but rarely. Snake Cactus adds textural diversity in gardens and thrives without much care from the landscaper.

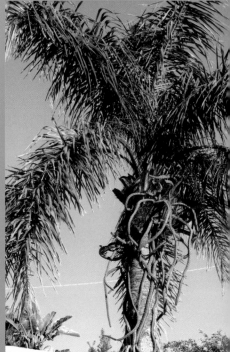

Pennisetum Setaceum
Fireworks Grass
or Purple Fountain Grass

Spring to Fall

Pennisetum Setaceum Fireworks grass is a red to burgundy annual grass.

A small ornamental, Fireworks Grass, lights up any garden with red-to-pink variegation. The plant develops shades of burgundy, pink, purple and red.

Fountain Grass is an annual plant in cooler regions but will re-sprout in warmer climates. A native of Africa, it is admired not only for its color but also for its grassy structure. It produces upright plumes in the fall, adding early winter interest.

African folklore relates stories of Pennisetum's ability to conceal and protect the spirits of tribal ancestors. The grass was not to be cut or burned, out of fear that ancestors would become angry. If the grass were cared for properly, ancestors favored the people who tended the grass.

Penta Lanceolata
Penta or Star Flower

Summer, Annual

Penta

A good bedding plant for a summer border is the Star Flower that is easy to grow and comes in a wide range of colors. An annual in the northern range of this book, it is a somewhat reliable perennial from southern Georgia into Florida.

Although native to Africa and the Arabian Peninsula, gardeners know the Star Flower as an American garden standard. Pentas are well suited to extremely hot and sunny conditions. The name Penta comes from the Greek word for five and refers to the five points at the tip of each flower.

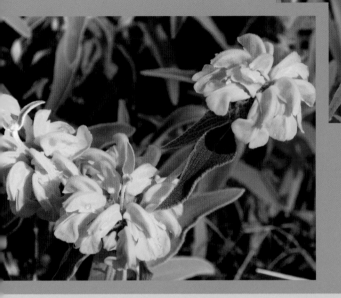

Phlomis Fruticosa
Jerusalem Sage

Spring to Summer

Phlomis

Jerusalem Sage
is a beautiful and
easy to care for
coastal perennial.

Jerusalem Sage
is an underutilized
perennial worthy of
more attention.

Displaying one of the most unique flower configurations, Phlomis has become an "in demand" perennial. The flowers open in a tightly whirled group around the stem that extends upward to where another flower cluster is displayed. This pattern repeats every few inches for the remainder of the inflorescence. The effect, called cluster stacking, is rare and desirable.

Several types of Phlomis have different colors, including yellow, violet, and pink, and its profuse flowers attract bees, birds and butterflies to the garden. The leaves vary according to variety, some displaying a fuzzy Lamb's Ear style while others have a standard matte green.

Native to the eastern Mediterranean area, Jerusalem Sage is grown in Israel for use in synagogues. It is a true Sage and has a long tradition that the stacking flower configuration is a ladder to a more peaceful world.

Phlox Ssp.
Phlox

Spring

Phlox

A garden tradition, the Phlox has been planted since Victorian times.

Common Garden Phlox

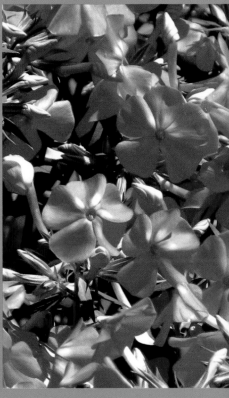

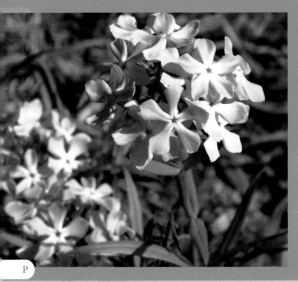

P

Phlox is an American garden favorite, growing from the east coast to the southwest desert. Since Phlox grows in tall and ground-cover varieties in a wide range of hues, there are many choices in color, shape and texture. Small, single flowers are the hallmark of this old-fashioned perennial. While not considered invasive, sunny conditions enable Phlox to spread out over a border. The Phlox flower attracts butterflies and moths as well as deer, rabbits and grandmothers.

In England, Phlox is a traditional flower to give during courting, as it signals romance in the springtime of its life. A white flower is the color of purity and reflects thoughts of marriage. A red flower indicates steamy passion on the giver's mind.

Phoenix Sylvestris

Date Palm or Silver Date Palm

Evergreen

Phoenix Sylvestris

Silver Date Palm

Native to India, where people have historically harvested dates for culinary purposes, the Silver Date Palm is widely cultivated for its fruit. Similar in structure and fruit production to the closely related Canary Island Date Palm (Phoenix Canariensis), this tree produces wrinkled, thick dates that can be eaten fresh upon harvest or stored for many months. The Silver Date Palm also produces sap that can be consumed fresh and fermented into an alcoholic drink.

Sacred in the Hindu religion, where its fruit and fronds have been offered to the gods for centuries, Phoenix Sylvestris is especially aligned with Kama and Rati, the Hindu god and goddess of love and sexual desire. Similar to Cupid in Roman mythology, Kama shoots toward Rati with a bow an arrow made from Phoenix Sylvestris, as he pursues her. According to Hindu tradition, his arrows were covered with Phoenix Dates and upon being hit with the fruit Rati would feel the sweetness of Kama's love. In India today, Dates are considered an invitation for romance and are a traditional wedding food. This Hindu story is the origin of the modern usage of the word "date" as the start of a couple getting together to consider romance.

Palm growers prize the Silver Date Palm for its relatively slim trunk, fast growth in sandy conditions and hot dry climates, and ease of care. Able to withstand high salt content and fierce winds, the Silver Date is a good choice for a Florida coastal landscape. The fruits from a Phoenix are medium sized and range in color from dark gold to rich brown.

Red Tip

Evergreen, Spring

Photinia

White Photinia flowers are a cherished southern favorite.

The Red Tip is a southern coastal native shrub.

The Red Tip is native to the eastern United States, where it was thriving when the first Spanish explores reached the southern east coast. Among the explorers was Lucas Vasquez de Ayllon, who is credited with discovering the Chesapeake Bay and James River in Virginia in the early 1500s. Vasquez de Ayllon saw the Red Tip shrub along the coast of Virginia, and thinking it was another biblical burning bush he followed it along the coast. Men in Vasquez de Ayllon's crew wrote that he would speak to the Red Tip and ask it for guidance. Only when new growth of the Photinia

matured and changed from red to green did Vasquez de Ayllon accept that this shrub was not the burning bush. However, he is thought to have been the first European to have named the plant Red Tip.

The Photinia is a large, dense evergreen shrub. In the spring, it produces large white flower cymes that are considered beautiful in the garden. The Photinia population was feared decimated a few years ago due to a disease that could not be controled and they fell out of favor with landscapers. The Photinia now seems to have made a recovery, as hundreds of healthy specimens can be seen growing along the east coast, and natural gardeners are encouraging landscapers to plant this grand, native, flowering shrub once again.

Photonia

Red Tip

P

Physocarpus Opulifolius
Common Ninebark or Ninebark

Year Round, Spring

Physocarpus Opulifolius

Common Ninebark is a magnificent member of the Rose family.

While many southern gardeners appreciate the flowers on this member of the Rose family, Ninebark has a beautiful secret. Hidden under green or burgundy leaves, woody tangled branches have beautiful exfoliating bark that resembles the Oakleaf Hydrangea. The bark splits and furrows with age, developing textured, irregular layers that led to its common name, Ninebark. Since this medium-sized shrub is deciduous, it displays its bark patterns over the winter months.

The Ninebark is an excellent plant for wildlife enthusiasts, as the spring flowers contain copious amounts of nectar and it is frequently visited by birds and butterflies. Ninebark is native to the United States. Native American people dug the roots of Ninebark to make a joint and muscle pain remedy.

Pinus Palustris
Long Needle Pine

Evergreen

Pinus

Pine Trees have long been a staple of the southern economy.

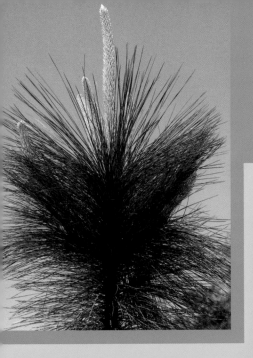

Pinus

New growth on a Pine Tree is called a "Candle".

A native of the southeastern United States, the Long Needle Pine is both an ornamental and a utilitarian Pine tree in coastal areas. Large stands of Long Needle Pine grow across the south, from Florida to Virginia and west to Texas. The stout trunk of mature specimens are considered beautiful, as are the long and soft needles on short and often crooked branches. This tree is shorter than the Loblolly Pine, its cousin. The Long Needle Pine is often planted in small groups of three to eight, as a small grove. New growth on this Pine is called a candle, for it resembles a pointed candle.

Simply planting fresh Long Needle Pine cones will not produce new trees. The seeds in the cone need to be subjected to the intense heat of a fire for a short time before they germinate and grow. In nature, wildfires fulfill this requirement, and large stands of Long Needle Pines can be seen sprouting quickly after a fire. **Authors note:** Wildfires are dangerous and unpredictable. Starting a wildfire, even with good intentions, is a crime and should not be tried. Seedlings are available in garden centers.

In folklore, this Pine is said to be "The sweetest of the trees," referring to the sweet acidic taste of its needles, which are edible and full of vitamin C. One legend tells of this Pine's entanglement with guilt. If you sleep among these Pines, you will awaken with nearly unbearable guilt that can be relieved only with humility to eat the soft, young needles of the Pine. This story has led to the familiar saying, "Swallow your pride to swallow your guilt."

The Long Needle Pine tree has many commercial applications. The bark and needles are sold as mulch. The wood is sold for flooring or other construction material. The sap is made into several types of industrial spirits, such as varnish.

Pittosporum
Clown Plant or Mock Orange

Evergreen, Spring

Pittosporum

The Pittosporum is widely planted around playgrounds.

An evergreen, Pittosporum provides bright winter color.

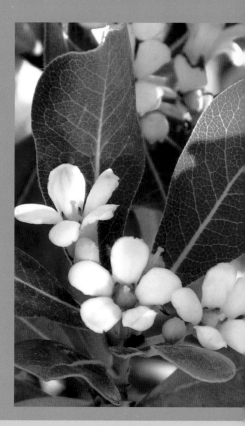

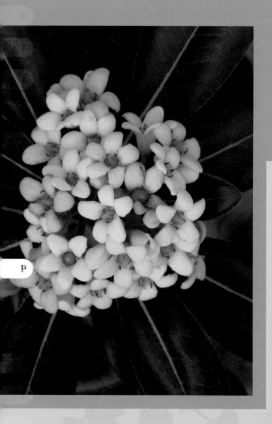

Able to withstand the harshest conditions, the Pittosporum can be planted on the beach and further inland with success. Variegated and all-green varieties are commonly available and require only sun and occasional waterings to thrive on the coast.

The Pittosporum is sometimes called Mock Orange, because the flower's scent resembles that of the Citrus. Pittosporum is not the only garden shrub to have this common name; the unrelated flowering shrub Philadelphus is also called Mock Orange, for the same reason.

Pittosporum sometimes is referred to as the Clown Plant, because of its round leaves and safe use around children. It has no thorns and is not poisonous; it is increasingly popular around playgrounds.

Its tolerance to salt and heat make the Pittosporum the perfect evergreen as a beachfront shrub. The Pitt, as local growers call it, is a thick, irregularly branched shrub that can reach nine or ten feet in height.

Platycerium
Bifurcatum
Staghorn Fern

Evergreen

Platycerium

The Staghorn Fern can become enormous under tropical conditions.

Native to tropical Africa, eastern Australia, New Guinea and New Caledonia, the Staghorn Fern most likely came to American shores on ships in the late 1700s or early 1800s. This large, evergreen fern is found in tropical and semi-tropical areas, and can be seen hanging in huge clumps under large trees throughout central and south Florida. Commonly planted in hanging baskets, Staghorn Fern can be grown with winter protection further north. The Staghorn Fern is an Epiphyte, or air plant, and does not need soil, as regular garden plants do. An Epiphyte lives solely from nutrients and moisture in the air. Another example of an Epiphyte is Spanish Moss (Tillandsia Usneoides). The Staghorn Fern has flat, hairy, irregular fronds that dangle down in antler-like patterns. A favorite plant for beginning gardeners, it is both interesting and easy to grow. Like all Ferns, the Staghorn does not flower, producing instead spores as a means of reproduction.

Poncirus Trifoliata
Flying Dragon or Hardy Orange

Year Round

Poncirus Trifoliata

Hardy Orange

The most cold hardy citrus, the Hardy Orange grows to zone 7.

P

summer brings hard, green fruit in clusters of two or three Oranges. Autumn is harvest time for the golf-ball sized Oranges that can be eaten right off the shrub. These Oranges are sweet and somewhat dry when compared with other oranges.

Its common name, Flying Dragon, comes from the shape of the branches that are said to resemble the dragon of Chinese folklore. Another common name is Hardy Orange. The tree has stunning fall color with tri-lobed leaves turning several hues of yellow. A deciduous shrub, the Poncirus has, like all members of the Citrus family, fascinating curved and pointed protrusions that resemble thorns. The sculptural growth habit of this plant makes it a show-stopper in a winter garden.

Poncirus is the most cold-hardy Citrus grown in America; it needs no winter protection. It is a true Orange and has a climate range from Florida to Virginia. Small, white flowers emerge in the spring and are held aloft on twisted, irregular branches. Bees and butterflies pollinate the Hardy Orange in mid-spring. The

Prunus Caroliniana
Carolina Cherry Laurel, Cherrylaurel or The Illegal Tree

Spring to Summer

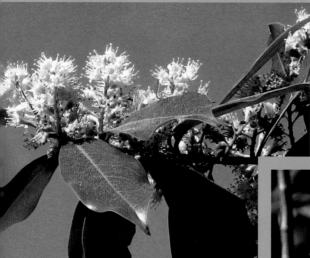

Prunus Caroliniana

"The illegal tree", Carolina Cherry laurel is both native and invasive.

Carolina Cherry laurel is a ubiquitous tree throughout the south.

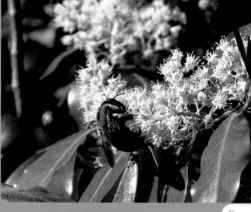

This is a southeastern native tree that grows in natural habitats from North Carolina south to Florida. Cherrylaurel is a medium sized with a nearly black trunk, glossy green leaves, puffy white flowers and black berries. The Cherrylaurel is considered an ornamental for its flowers, but produces no distinguishable fall color.

The Carolina Cherry Laurel is, in the state of Georgia, sometimes called "The Illegal Tree." It is listed as an A1 invasive plant in Georgia, where it is illegal to buy, sell or transport. The hundreds of berries that it produces each year have a ninety-nine percent germination rate, making it one of the most invasive trees in the southeast.

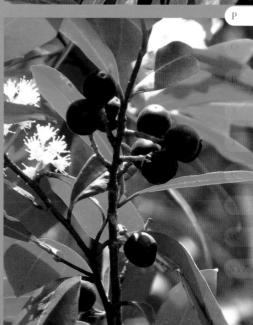

Pseudogynoxys Chenopodioides

formerly known as Senecio Confusus

Mexican Flame Vine or Orange Glow Vine

Spring

Pseudogynoxys Chenopodioides

The red to orange flower of the Mexican Flame Vine is awe inspiring.

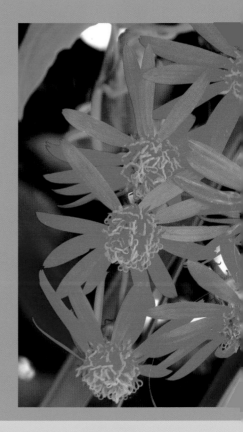

The Aztec peoples of ancient Mexico venerated the Mexican Flame Vine for its association with the sun and the spirits of the dead. Sun worship was a common part of Aztec religious practices and the bright orange flower of the Flame Vine was a powerful symbol. In Aztec folklore, souls of the departed became one with the sun and together they watched over the living through the flowers of this vine. A single plant might contain dozens of flowers which would represent many generations of ancestors. Along with the flower, the vine is important in these stories. The tangled mass of stems provided pathways for the souls of the departed to communicate with each other. This botanical watchtower insured that any transgression would be exposed to the wrath of the sun god.

Flame Vine is an evergreen vine found in central and south Florida. In north Florida and along the Georgia coast it is a die-back plant that regrows from the ground each spring. Once established, the Mexican Flame Vine, a member of the Aster family, is drought tolerant and should never need water. Gardeners like this vine for its relatively compact growth habit.

Pyrrosia Lingua
Tongue Fern

Evergreen

Pyrrosia Lingua

The Tongue Fern is a close relative
of the Resurrection Fern.

Many gardeners have a hard time believing that this stiff-textured groundcover is actually a Fern. This low growing plant got its botanical and common name from the shape of the frond; the Tongue Fern looks like a tongue but feels like a Magnolia leaf. Pyrrosia comes from the Greek word *Pyrros*, which means red and refers to the reddish tint of the hairs on some of the Pyrrosia species. *Lingua* is Latin for tongue.

The Tongue Fern is native to China, Taiwan and Vietnam. This shade-loving Fern is easy to establish in southeastern coastal gardens. The rhizomes form thick mats of upright evergreen fronds. It can be seen from New Bern, North Carolina to Jacksonville, Florida. Tongue Fern also makes an excellent hanging basket plant.

Ornamental Pear or Bradford Pear

Spring to Fall

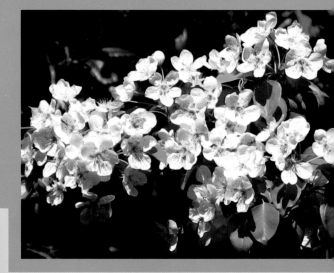

Pyrus Calleryana

Pear Tree

The Bradford Pear is the most beautiful trash tree in the American landscape. It has profuse white flowers in the spring, a symmetrical form when young, is a medium-size tree, readily available and with fantastic fall color. The ornamental Pear was planted by the thousands when new subdivisions were being built in the early nineteen nineties. At the time, these Pear trees looked well and grew fast, giving a new subdivision an older look quickly. But, the Bradford Pear has very weak wood; they split out at the crotch point, so wind or an ice storm irreparably damages them. Unlike most trees, the Bradford Pear does not repair itself. The damage quickly leads to diseases, rot and insect infestations. Gardeners get about fifteen years of enjoyment from a Pear tree before replacement becomes necessary. Also, they are susceptible to disease and insect problems even without visible damage. Educated gardeners and landscapers no longer plant them. A saying in the landscape business is, "A chainsaw and a stump grinder will clear that right up!"

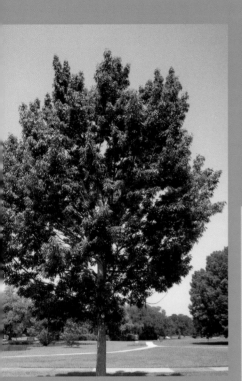

Quercus Acutissima

A medium sized Oak, the Sawtooth Oak is perfect for small yards.

As an underrated tree for the urban landscape, the Sawtooth Oak has many features for modern design plans. The Sawtooth is a fast-growing, shade tree that can, if planted to the south and west of a house, lower the homeowners cooling costs significantly. A house that is shaded by large trees never heats up as much as a house in full sun. Gardeners have a saying about shading a house; "Grow an air conditioner."

The Sawtooth Oak has a fairly regular branching pattern, that appeals to the neat, orderly look of modern neighborhoods, while retaining a natural form. Whether a sole specimen or planted with other trees, the bright green leaves of the Sawtooth Oak complement a wide range of architectural styles as well as different types of gardens.

The leaves of the Sawtooth turn russet brown in the late fall and stay attached to the branches throughout the winter, releasing only as new growth pushes them off in the spring. The leaves are sharply serrated at the margins, leading to the common name, Sawtooth.

The Sawtooth Oak is native to China and southeastern Asia and was brought to America in the early 1900s as a wildlife foodsource. The acorns are small, prolific and germinate readily, but do not begin to develop until the tree is several years old. Squirrels, mice and deer feed on the acorns of this Oak. Due to human planting and seed germination, the Sawtooth Oak has naturalized in many parts of the eastern United States.

Oaks have a long history in folklore and mythology, with Oak stories reaching back to early habitation. In China, the Oak is said to be a barer of the suns. When the sun rises an acorn is produced, when the sun is at its height, the acorn looks over the countryside, and when the sun sets, an acorn falls to earth. When a thousand Oaks become a forest, one century has passed. This legend is one of several early calendars used in ancient China.

Quercus Virginiana

The magnificent and historically important Live Oak.

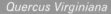

The Live Oak is a massive, sprawling tree that got its common name because it is an evergreen. Even in the darkest days of winter, the Live Oak has a full green canopy of leaves held aloft on twisted, irregular branches. Live Oak trees often host other plants, such as Spanish Moss and Resurrection Fern.

A southeastern native tree, the Live Oak was first described at Shirley Plantation near Williamsburg, Virginia, in the late 1600s. Virginia is the northern end of this Oak's range, as it prefers warmer coastal climates and grows well all the way to Florida.

Historically, the Live Oak was grown in groves to supply the cargo and passenger shipbuilding industry with wood to be used for the frames. Port cities along the southern east coast, such as Norfolk, Wilmington, Charleston, Savannah and Brunswick, all needed Live Oaks to support their main economic industry.

Robert Ruark, a Wilmington, North Carolina author and columnist from the mid 1900s, featured a Live Oak on the cover of his 1957 book, *The Old Man and the Boy* (Holt). The book presents classic stories about a boy and his grandfather living in coastal North Carolina. Many of them make reference to the Live Oak and other coastal plants.

Lady Palm

Evergreen

Rhapis

The Lady Palm

A native of eastern China, the elegant Lady Palm has been a sought-after ornamental since the late 1700s. As early as 1802, Japanese aristocrats began to collect the Lady Palm for use in palaces and estate homes, and its popularity spread rapidly around the world. The Lady Palm tree shown here was photographed in the gardens of the Cummer Museum in Jacksonville, Florida.

This upright, clump forming Palm makes a sophisticated addition to a coastal Georgia or Florida garden. The slow growing Rhapis Palm requires only dappled shade and occasional watering. In coastal gardens north of Tybee Island, Georgia, the Lady Palm needs heavy winter protection, as it is subject to damage from multiple nights of frost.

Victorian parlors and grand entrance-ways have been embellished with Lady Palm trees for many generations. Due to its sophisticated reputation, fancily decorated pots are often used to display the Lady Palm. An easy-care houseplant that thrives in the lowest light, Rhapis will draw the attention of house guests and curious cats alike.

R

White Locust or False Acacia

Spring to Fall

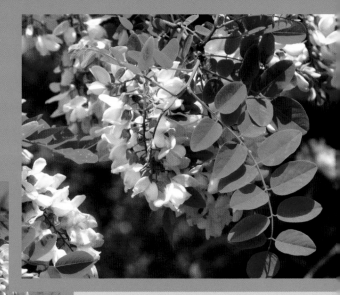

Robinia

The Robinia produces flowers in colder weather.

to last a hundred years or more. The frontiersmen would also have favored Robinia as firewood, for it burns slowly without producing much smoke or visible flames.

The botanical name, Pseudoacacia, means false, and refers to the seed pod's resemblance to that of an Acacia. The White Locust is closely related to the Black Locust.

While the stunning white flowers and late summer seed pods might strike the fancy of coastal gardeners, caution should be taken when considering this plant for an ornamental border. The branches of the White Locust can be brittle; gardeners have noted its ability to self-seed rapidly. The White Locust, a member of the Legume family, will grow in USDA Hardiness Zones 4 - 9.

The Robinia Pseudoacacia is widespread throughout North America, with old growth specimens ranging from central Illinois to Georgia. Historians believe that frontiersmen, such as Daniel Boone and Davy Crockett, spent time splitting Robinia logs for fences and railings. The wood of the White Locust contains Flavonoids that retard the rotting of the wood and help to preserve it, even when used in the ground. White Locust fence posts are known

Roystonea Oleracea
Royal Palm

Evergreen

Roystonea

A truly Royal palm.

The Royal Palm, associated with wealth and status, is commonly planted at lavish estate homes across its native southern Florida and the Caribbean. An elegant plant by any measure, the Royal Palm can be seen in upscale landscapes from Key West to Melbourne. The Royal Palm resembles a Foxtail Palm, but is more substantial in overall size; its most notable feature is its smooth, green boot just below the frond set. In palm terminology, a boot is the part of the frond that attaches to the main trunk. Another attribute of this palm is its ability to shed its fronds easily, giving the Royal Palm a clean, neat appearance. A true tropical, the Royal Palm does not withstand much frost and becomes rare north of Cocoa Beach.

The Coco Palm (*Cocoa Nucifera*) is a companion plant with Royal Palm and the two are often planted together. The Coco Palm produces Coconuts, while the Royal Palm does not develop a culinary fruit.

The Genus Roystonea was named for Union Civil War veteran and U.S. Army engineer Gen. Roy Stone. Several years after the Civil War, Gen. Roy Stone founded the Office of Road Inquiry (ORI) within the Dept. of Agriculture. The ORI developed the American highway system that was later expanded by President Eisenhower in the 1950s.

Elegant Ruellia or Cardinal's Ruellia

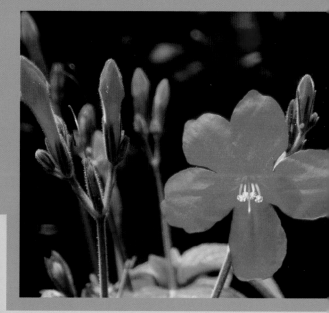

Ruellia Elegans

The deep red offsets white in the garden.

A close relative of Mary's Flower, the Elegant Ruellia is a Mexican native and standard in eastern landscapes. A heat and humidity tolerant perennial, the Elegant Ruellia has bright, rich-red flowers in a single, four-petal configuration. Matte green leaves form a thick backdrop for this spring flowering stunner. Elegant Ruellia, like Mary's Flower, develops thick patches in the garden. Propagation is easy, with division and cuttings almost always successful.

Just as Mary's Flower has a strong association with the Catholic religion, Cardinal's Ruellia also has a bond. In the late 1500s and early 1600s, as Catholicism was being introduced to Mexico by the Spanish, the explorers were shown Ruellia, a plant that the natives had been using as a dye for centuries. Needing to make new vestments, the Spanish used the red Ruellia flower to color the Cardinal's cloaks. Ruellia flowers made a deep, blood-red dye of such good quality that samples of it exist to this day. The flower's use as a dye is most likely the source for the common name Cardinal's Ruellia, while the name Elegant Ruellia comes from its use among the Catholic clergy.

Rumex
Blood Sorrell

Spring to Fall

Rumex

Blood Sorrel can be used as a perennial and a groundcover.

Rumex is a small perennial that got its common name from its blood-red veining along the leaves.

In Pagan tradition, the Blood Sorrell is a sacred plant said to contain the blood of the natural world. Pagan theology states that blood is life, so the Blood Sorrell represents that belief. In Pagan ritual practice, the Blood Sorrell is cut open and tasted as a means of taking in the life of nature. This consumption is a manner of venerating nature and the gods that rule over it.

Sabal Palmetto
Sabal or Cabbage Palm

Evergreen

Sabal Palmetto

The Cabbage Palm.

The Sabal Palm is a standard along the coast.

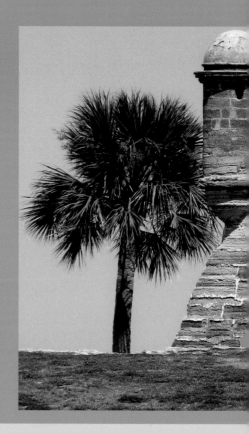

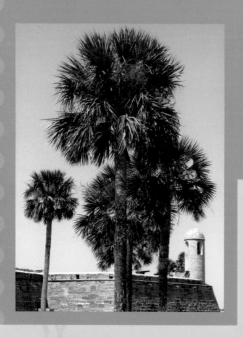

Despite the generic name Palm Tree, Palms are not actually trees. All Palms are members of the Grass family and are related more closely to Wheat, Rice, and Sugar than to trees. The Grass family is the largest plant family, and eight of the ten foods that stand between man and starvation are Grasses. The Sabal Palmetto is the source for Heart of Palm, a commonly sold vegetable; the plant's other common name,

Cabbage Palm, also comes from its association with vegetables.

Historically, port and dock builders along the eastern coast used the trunks of Sabal Palms for piles, deep or shallow foundation supports for docks. Because the trunks of Sabals are fibrous and flexible, they are able to withstand the motion of the water while providing stable support. A Sabal Palm pile can, under good conditions, last for decades.

The Sabal Palmetto is the state tree of both Florida and South Carolina. Sabals are a beautiful addition to any coastal garden, but remember that they are painfully slow growing and it can take years for them to become showy in the landscape. The Sabal Palmetto is rare in coastal Virginia, but becomes more common further south.

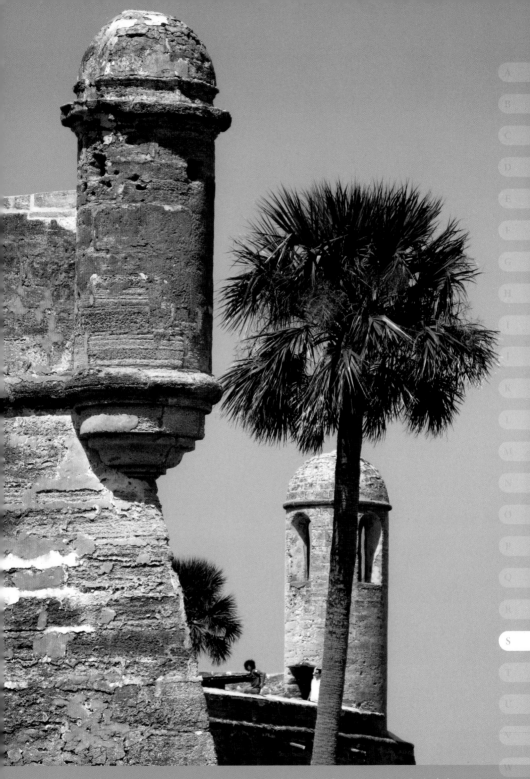

Sabal Palmetto

Natives once used the Sabal fronds to thatch their houses.

Salix Babylonica

Weeping Willow

Summer to Fall

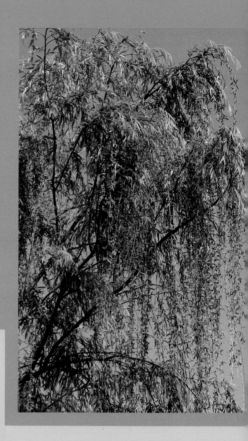

Salix

Beware the water pipes,
Salix soaks up water

The Weeping Willow is a tall tree with a strongly weeping form. Its long slender branches reach down from the upright trunk. A graceful tree, the Weeping Willow is planted as an ornamental specimen to great effect. Slim, narrow leaves shimmer and contort in even the slightest breeze.

Landscapers need to be careful where a Weeping Willow is planted, as the roots are aggressive in seeking out water and can sometimes cut into water lines in an urban garden. Coastal regions tend to have high water tables, making them suitable to supporting Weeping Willows. This tree will grow in dryer as well as riparian areas with high alluvial concentration.

This tree is native to wet areas of the Middle East and was named after the city of Babylon. It is sacred in the Jewish tradition and included in the fall festival of Sukkot as part of the religious service. Four species of plants are bound together and called The Lulav, including Willow, Myrtle and Date Palm fronds, along with a citrus called an Etrog. They are known to be a representation of the harvest.

Sambucus Canandensis

Elderberry or Common Elder

Summer to Fall

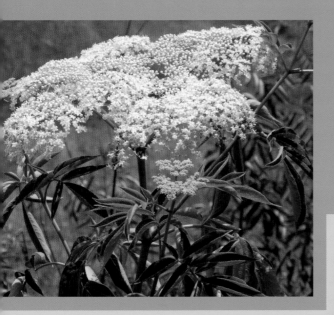

Sambucus Canandensis

The Elderberry is steeped in folklore.

Living a shadowy existence under canopies of dark forests, the Elderberry came to have supernatural associations. In Northern Europe it was believed to be possessed of a spirit and no one could destroy Elderberry without peril to themself.

The name is associated it with Hulda, or Hilda, the mother of elves and good woman in Northern mythology. In Denmark, Norway and Sweden, Hulda lived in the root of the Elder, so the shrub was her symbol and was used during ritual ceremonies of her worship.

It was forbidden to employ Elderberry wood in the construction of houses, because the occupant of such a house would feel the spirits pulling in his legs, a terrible sensation that could only be relieved by planting three Elderberry shrubs in the forest and assuring their life until mature enough to flower.

Traditionally, Elderberry is said to cure toothaches and fend off snakes, mosquitoes and warts. It quiets nerves and interrupts fits of madness, keeps fleas out of furniture, removes poison from metal utensils and guarantees that he who cultivates it shall die in his own home. While the large white Elderberry flowers were said to represent the purity and brightness of enlightenment, its black berries were gobbled up by all manner of fairies, elves and warlocks. Elderberry wine has long been a traditional drink in many cultures.

Despite these enchanting myths from Europe, Elderberry is native to the Eastern United States, making it a valuable addition to any native garden.

Santolina Sempervirens

Santolina or Green Lavender Cotton

Year Round

Santolina

Santolina is one of the most fragrant evergreens for the coastal area.

"The rarity and novelty of this herb, being for the most part in the gardens of great persons, doth cause it to be of great regard. "
— John Parkinson

One of the most fragrant plants in coastal gardens is the Santolina, which has a strong, sweet scent. Whether brushed by hand or wind, this small evergreen shrub will fill the garden with a pleasing aroma year-round. Santolina is native to southern Spain in the Mediterranean Sea, where its fragrant foliage protected the plant from grazing wildlife. Santolina Sempervirens became known in medieval times for its use in knot gardens. Plants such as it were grown at fortified castles to provide residents with fresh herbal cuttings to disguise unpleasant odors.

Santolina has yellow flowers that emerge in late spring and add stunning beauty to the fragrance. The flowers, a favorite of florists today, are often used in dried floral arrangements.

The Santolina is easy to care for, needing to be watered regularly only for the first year; Santolina thrives solely on rainwater thereafter, grows well in full sun and are not fussy about soil conditions. They almost never need pruning, but form small clumps that contrast with ornamental rocks or brick garden walls. Companion plants for Green Lavender Cotton are Sage and Yarrow.

Sarracenia Ssp.
American Pitcher Plant
or Trumpet Pitcher

Spring to Summer

Sarracenia

Pitcher Plant

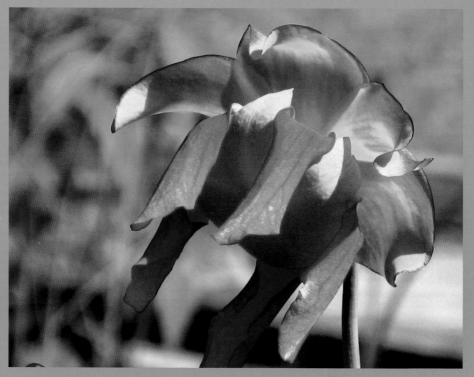

Trumpet Pitchers are native American, carnivorous perennials that lure insects with nectar and then consume the insects; they use their tubular-shaped leaves as an enzyme-filled trap. Insects crawl into the leaves looking for nectar and cannot escape. Some types of Sarracenia use downward-pointing hairs or sticky secretions to make it difficult for the insects to get away. Pitcher plants grow in nutrient deficient, often acidic soil and use insects to fortify their nutritional needs. Their flowers range from yellow to blood red, a color especially meant to attract insects. The pitchers do not grow a regular root system, but develop a rhizome that stores food and spreads underground. The plants die-back over the winter, returning each spring to continue the cycle. Pitcher Plants grow mostly in Sphagnum bog habitats where water is plentiful, but they can be seen growing in drier fields.

Pitcher plants, by design, attract a wide range of insects, including ants, butterflies, flies and even spiders. Small woodland frogs

American Pitcher Plant or Trumpet Pitcher (*continued*)

Spring to Summer

Sarracenia

Pitcher Plants grow best in wet conditions.

There are many colors of Sarracenia for the gardener to choose from.

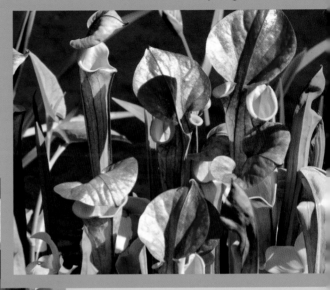

sometimes hide in the tube of the Pitcher Plant, feeding on the flies that get trapped inside.

Tall tales and folklore stories abound about flesh-eating plants like the Pitcher Plant. One tale tells of Michael Backman, an explorer in the marshes of North Carolina, who resisted the advice of his guide and set off on his own to investigate an area before the sun rose over the water. Mr. Backman was found some weeks later... well, his big toe was found some weeks later. The following spring, locals noticed that the Pitcher Plants were thriving and to this day the ghost of Michael Backman can be heard among the Pitchers.

The purple pitcher plant is the official flower of Newfoundland and Labrador.

Scabiosa
Pincushion Flower

Spring

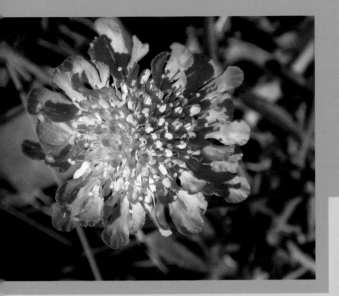

Scabiosa

The traditional Pincushion flower has been planted for decades.

Scabiosa plants have multiple, small flowers that range in color from subtle lavender blue to soft white. With their many layers of petals, the flowers are held erect as a single head on a tall stalk and are a good source of nectar that attracts insects, including bees, months and butterflies. Wildlife gardeners are drawn to Scabiosas for the abundance of critters they attract, while low-maintenance gardeners like the lack of care they require. A part-sun location and water supplied weekly for their first year is required; after that, the spent plant needs to be cut back once in late fall. Scabiosas will bring years of enjoyment to gardens both on the coast and inland.

Old-fashioned Pincushion flowers have been growing in America for centuries. The common name Pincushion comes from a Virginia gardener who recalled in an almanac article that her mother used one as a pincushion while sewing clothes in the garden. The article was published in the late 1870s and gardeners have called this flower Pincushion ever since.

Schefflera
Umbrella Tree

Evergreen

Schefflera

America's lobby plant is actually a tropical shrub.

This tree is sometimes called America's lobby plant, because it frequently is used in waiting rooms or lobbies as foliage decoration. Schefflera is grown throughout the world as a houseplant that does not flower, but has all-green and variegated specimens. On the coast of Florida, the Umbrella Tree is a semi-tropical landscape plant; although, with protection in the winter, smaller specimens can grow outdoors as far north as Hilton Head Island, South Carolina.

With large leaves in displays of five or six to a terminal bud, the leaf set is a unique identification feature resembling an umbrella, leading to the common name. Scheffleras can reach over twenty feet in height and flower in sprays of red to burgundy, under ideal conditions. A multi-trunked evergreen, the Schefflera is a dieback shrub in Florida on the northern end of its range.

Schoenoplectus
Tule or Bulrush

Evergreen, Spring

Schoenoplectus

Tule is found along rivers and wetlands on every continent. In North America, it is used as an ornamental grass and to stabilize marshes and ponds. In India, Tule is harvested, dried and cracked open for use as cording. In South America, Tule seed heads are collected and made into a type of flour for bread-making. In Africa, Tule is used as a building material for thatched roofs, and its fibers are used as a mud compound to make walls stronger.

Schoenoplectus has another common name, Bulrush, because of its resemblance to Rush, an unrelated wetland plant. In another application, the fibers are used to make bullwhips. The Biblical story of Moses specifies that the basket containing the baby (Moses) was hidden among Bulrush stands along the Nile River banks in Egypt.

Virginian Skullcap

Spring

Scutellaria Lateriflora

Virginian Skullcap is an old fashioned favorite.

A native of eastern America and a member of the Mint family, Virginian Skullcap traditionally has speckles inside the flower. A prolific perennial in the Virginia garden, the Scutellaria got its common name, Skullcap, from the shape of the Calyx. Flowers of the Virginian Skullcap are usually not borne at the end of the stem, but along its length, giving the plant a relatively dense texture. Like most members of the Mint family, Virginian Skullcap is edible, having a sweet peppermint flavor. It attracts bees and beneficial insects to the garden. The Virginian Skullcap will need to be cut to the ground in early winter and a light layer of mulch applied to the area, but is a reliable perennial.

Virginian Skullcap has been used in traditional folk medicine for generations. External aliments said to be relieved by Scutellaria include rashes, scrapes and acne. Internal issues can be treated by steeping Virginian Skullcap into a brew. The complaints commonly treated with Scutellaria brew are upset stomach, nausea and heartburn.

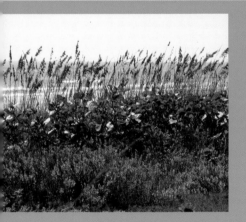

Sea Oats

Seaside Grass

Seaside Grass

The grass family is the world's largest.

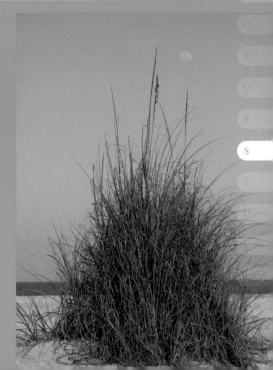

Serenoa Repens

Saw Palmetto or Scrub Palm

Evergreen

Serenoa

The Saw Palmetto stabilizes banks along the East Coast.

Saw Palmetto is one of the most prolific palm species in North America. Also known as Scrub Palm, it has a low-growing, clump-forming growth habit. In time, the Scrub Palm will form colonies that can cover several acres. It can be seen as an unde- story plant along highways and riparian areas from Savannah, Georgia, to Miami, Florida. The jagged trunks are small in diameter and usually run along the ground in several directions for a few feet before curving upward another three to four feet. The palm-style fronds, ranging in color from green to silver, have small, sharp teeth along the length of their petioles from which the common name, Saw Palmetto, originated.

Historically, Saw Palmettos were used in colonial days as weapons by both British and Spanish soldiers. As a native plant, Saw Palmetto would have been available on the battlefields along the coasts of Georgia and Florida. The strong, ridged teeth would make a formidable weapon in battle. Saw Palmetto was also used as a tool to cut deerskin, pelts and grasses. An extract from the Scrub Palm's fruit has been used in medicinal formulas for centuries.

132

Smilax ssp.
Greenbriar or Wedding Vine

Evergreen

Smilex The Smilex vine is both fun and invasive.

Southerners have used this evergreen vine as archway trellis foliage at weddings for decades. Dark glossy green leaves with light white marbling make a long-lasting addition to floral wedding décor. Wedding Vine's best attribute is its ability to stay green and turgid for several days after cutting. Their length, over twenty five feet, makes this a perfect choice for garlands, as well. Due to its invasive nature, Wedding Vine is not available at garden centers and must be taken from the wild.

Also known as Greenbriar, it is a thick, substantial evergreen vine that will take over trees and shrubs if it is not pruned. It grows from underground tubers that resemble both Sweet Potato and Ginger Root. Pruning requires a gardener to dig up the entire tuber and remove the Greenbrier.

Sophora, Kowhai or Necklace Pod

Spring to Summer

Sophora

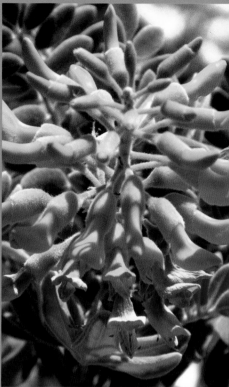

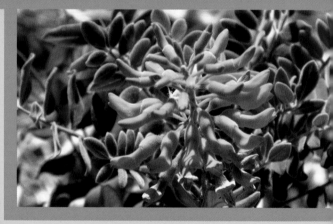

Native to a large area that includes New Zealand and the Pacific Rim, Sophora has been grown in tropical and subtropical areas for centuries. In America it is also know as Necklace Pod, and growers in the South Pacific area call it Kowhai. In Florida it is planted as an ornamental shrub that is valued for its yellow spring flowers and lacy leaf structure.

The botanical name, Sophora, is derivesd from the Arabic word "Sophera," meaning Pea Tree, because it is in the Pea family, Fabaceae. It is closely related to the common Pea that Americans eat as a vegetable.

Spartina Alterniflora
Saltmarsh Cordgrass

Evergreen

Spartina Alterniflora Cordgrass

Many areas of the southern east coast have beautiful marshes that are an essential part of the ecosystems, especially along the Georgia coastline from Tybee Island to Brunswick. These marshes have inspired many writers, poets and visitors through the years. Saltmarsh Cordgrass is a most prolific plant with long, slender blades that grow in both brackish and saltwater, easily adapting to marsh conditions. Although an evergreen, Cordgrass can appear dormant in winter months, while in the spring and summer it waves across acres creating stunning vistas.

The beauty of the marshes in Glynn County, Georgia, inspired Sidney Lanier to write his most famous poem " *The Marshes of Glynn,"* in 1875. Memorization of the long and famous poem was once required by school children in Glynn County.

St. Augustine

St. Augustine, Florida

Stewartia
Stewartia or Stuartia

Spring to Fall

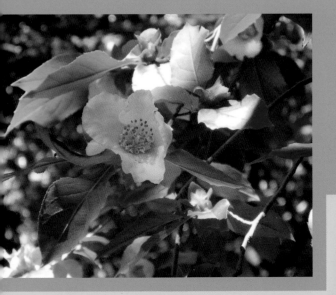

Stewartia

Thomas Jefferson noted Stewartia is his journals.

A member of the Theaceae Family, Stewartia is closely related to the Camellia and is native in southern Asia. Ruffled flowers and a yellow stamen set reveal the Stewartia's identity, making this small tree a favorite of southern coastal gardeners.

The Genus was named by Swedish botanist Carlos Linnaeus in 1753 to honor John Stuart. Taxonomists have an ongoing debate about the spelling of *Stewartia*, with some spelling it *Stuartia*. However, Linnaeus consistently used *Stewartia*, so the majority of taxonomists in America accept that spelling.

The Stewartia prefers shade with acidic and consistently moist soil. A southern tree, Stewartias cannot withstand consistently freezing temperatures. The small, profuse flowers emerge in late April and continue into May. A Stewartia will develop rough, reddish-orange bark and a circumference of more than one foot, with age. Stewartias are rare as normal garden center stock and will most likely need to be special ordered, but they are available.

Stokes' Aster

Spring to Summer

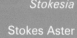

Stokesia

Stokes Aster

Stokes' Aster was first discovered in southeastern coastal areas from Myrtle Beach, South Carolina, south to St. Augustine, Florida. It grows in wetlands, pine woods, open fields and riparian areas that have naturally acidic soil. A hardy perennial flower for coastal regions, Stokes' Aster is an old fashioned plant with a long tradition in the garden. Native and wildlife gardeners are attracted to its beauty as a durable member of the Aster family

The strictly ornamental garden is a relatively new development; non-edible plants were formerly dug up in the wild. Before cultivated plants and hybrids were introduced for sale, a gardener would plant whatever was in their neighborhood naturally. The Stokes' Aster was one of the early ornamental introductions. Its interesting ragged edge of the radiant sepals, as well as its evergreen leaves first attracted growers. Not until years later were new cultivars grown. Originally the flowers were purple, but a new white variety is available today.

Strelitzia
Bird of Paradise

Spring to Fall

Strelitzia

The classic Bird of Paradise can be seen in Florida and Georgia.

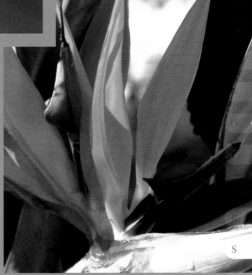

The Bird of Paradise is a large, tropical evergreen found in Florida landscapes. The spring flower of the Strelitzia, with gorgeous motley color, is its most sought after and highly regarded attribute that appears to be a tropical bird. The common name, Bird of Paradise, comes from the shape of the sunbird-pollinated flower. When not in blossom, the plant displays large, upright, oar-shaped leaves that sway gently on tropical cross-breezes.

The plant is native to South Africa where it is called the Crane flower, and it is associated with liberty, justice and common sense. The large Strelitzia plant is placed near warm-climate pools and patios for its care free, tropical appearance.

Syagrus Romanzoffiana
Queen Palm

Evergreen

Syagrus Romanzoffiana

Queen Palm

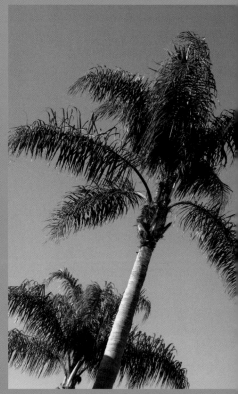

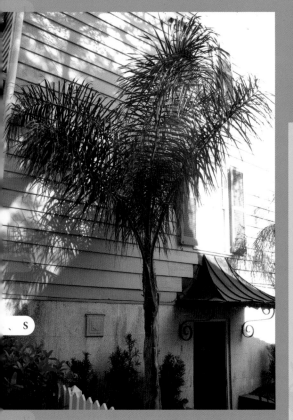

Native to South America, the Queen Palm is a relatively tall tree noted for its long boots and wispy fronds. As compared to other palms, the Queen Palm has a rather smooth trunk that adds textural diversity to the Florida and Georgia landscape. Its overall appearance resembles the Coco Palm (*Cocos Nucifera*), but it does not produce the same type of coconuts.

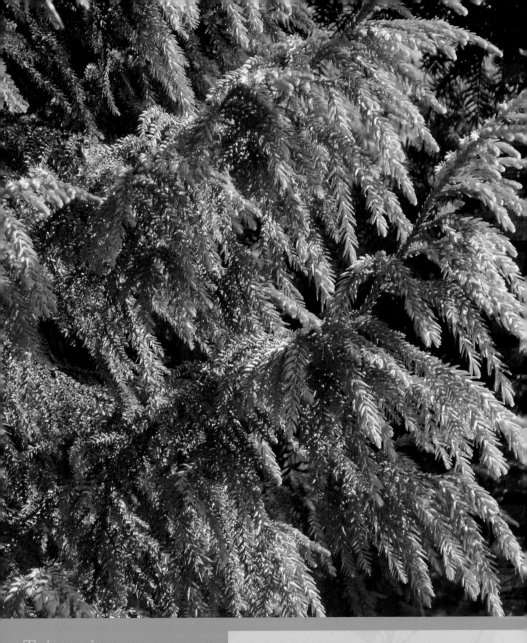

Taiwania Cryptomerioides
Coffin Tree

Evergreen

Taiwania Cryptomerioides

The Coffin Tree was historically used to build coffins.

As the botanical name would suggest, the Coffin Tree has a long history in its use for making coffins. A strong, upright evergreen, it resembles Hemlock. The Taiwania Cryptomerioides is one of a few needle-producing evergreens native to Taiwan.

141

Tamarix
Tamarix or Salt Cedar

Evergreen, Spring to Fall

Tamarix

The Salt Cedar is one of the most reliable coastal plants, due to its ability to withstand salty coastal conditions.

Native to northern Africa and southwestern Asia, the Salt Cedar's common name derives from its tolerance to salt water, but it is not a true Cedar. Because of its full-sun requirement, Tamarix makes a good addition to beach-front landscapes. It likes to be dry, so planting it in high or well-drained sites above the littoral zone is essential. Homeowners who are concerned about dune erosion should consider the Tamarix as a natural solution that can be planted alongside Sea Oats.

The flowers of the Tamarix are small and clustered tightly along the top length of the many upright branches. A summer-flowering evergreen that can reach eight feet in height, the Tamarix shrub requires little maintenance while providing great beauty.

Tanacetum Vulgare

Tansy
or Mugwort

Spring to Fall

Tanacetum

Tansy is a historically important herb, grown for centuries for both its medicinal and religious value.

143

Appreciated since ancient times, Tansy is an herb with many qualities and many stories.

One such story comes from the Protestant tradition in Europe and tells of Tansy's connection with the Easter holiday. The Rectors and Bishops used to play ball with the men in their congregation and a Tansy pastry was the prize for the team that was victorious. The pastry was made from young Tansy leaves mixed with eggs and flour.

Tansy or Mugwort (continued)

This pastry was thought to assuage hunger of the stomach after the Lenten season. It came to be the custom to eat Tansy pastries on Easter day. In time, the pastry eating custom became symbolic of the bitter herbs eaten by the Jewish community at the time of Passover. A seventeenth century writer noted that Tansy should be consumed in the spring as a supplement to the salt fish eaten during Lent.

Tansy also is known for several traditional medicinal benefits. Medical practitioners since the 1500s have written about Tansy's ability to help reduce swelling caused by gout. Tansy also was noted by doctors as successful in counteracting the ill effects of winter's damp and cold. Tansy remedies for nerves, hypertension and headaches all have been recorded.

In the late 1800s, a butcher wrote to his local newspaper to tell the people of the Tansy's use in his butcher shop. According to his letter, his daughter brought Tansy cuttings into his shop one day and laid them on the meat counter. Within minutes the counter was clear of flies. The butcher then told his daughter to bring in all the Tansy cuttings she could find until they filled the shop and not a fly was to be found. Soon, customers began to comment on the clean shop and fresh herbal flavor of the steaks. The butcher wrote that the Tansy cuttings had increased his business sevenfold. As a result of the newspaper article, townspeople began to plant Tansy outside their doors to keep the flies out of their homes.

For the modern gardener, Tansy herb is a wonderfully robust garden perennial widely known as an insect repellant. Planting it in the urban ornamental garden is productive for keeping all manner of insects away. Unfortunately, it drives away beneficial insects as well. Fruit, vegetable and natural gardeners can enjoy the benefits of Tansy's insect-repellent qualities by wearing Tansy clippings on their clothing while working in the garden, without permanently removing beneficial critters. Although generally grown for its leaves, Tansy does blossom in late summer or early fall with multiple pom-pom flowerheads. The flowers are bright, clean yellow in color, and Tansy makes an excellent dried flower.

Tecomaria or Cape Honeysuckle

Spring to Summer

Tecoma

Cape Honeysuckle

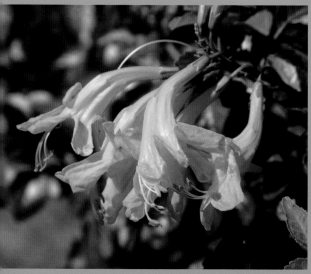

Tecoma

Showy flowers mask the Cape Honeysuckles invasive nature.

Cape Honeysuckle is native to Africa. Although many gardeners think it is stunning, Tecomaria is an aggressive and invasive vine in Florida, yet much more manageable in Georgia and South Carolina where it is a die-back vine in those areas.

Tecomaria comes in a number of colors: orange, red and yellow, as well as several hues in between. The flowers are the size of an Azalea's flower, but more closely resemble a member of the mint family.

Trachycarpus Fortunei
Windmill Palm

Evergreen

Trachycarpus Fortunii

Hardy into zone 7, the
Windmill Palm is cold resistant.

Slow growing, the Windmill Palm
is a lesson in patience.

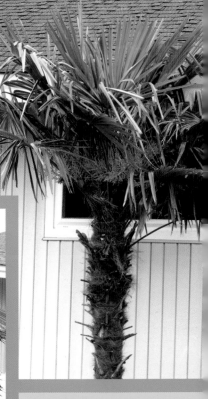

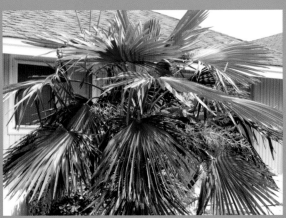

The Windmill Palm, cold-hardy in North Carolina and Virginia landscape, gives the mid-Atlantic border a tropical feel. A slow-growing but incredibly hardy palm, the Windmill can withstand both wind and salt spray at beach-front locations and long cold spells further inland. The common name, Windmill Palm, comes from its Windmill-like shape of its frond. Like all palms, the Windmill Palm develops small yellow flowers in the spring and seeds in the late summer. This is not a Coco Palm, and therefore is not coconut-producing.

A native from central China to Burma, the Windmill is the most popular landscape palm in America today. Enthusiasts from Virginia to Florida like both its durability and small size. The average height of

this palm is around twenty feet, but specimens have been measured at thirty feet tall. The Windmill Palm has a rather small canopy compared to other palms and a narrow trunk covered in what is known as Coco fiber. In America, the fiber is used to line meta- framed window boxes, while in China and Japan the fiber of this palm is used to make baskets, rope and netting that require a strong, long-lasting material.

Common in Europe, the Trachycarpus Fortunei was introduced to Germany by Robert Fortune in 1850, and the species was later named Fortunei in his honor. The Windmill Palm made its way into American landscapes from Europe in the early 1900s.

Uniola Paniculata

Sea Oats

Spring to Fall

Uniola Paniculata

Sea Grass

A classic beach-front beauty, Sea Oats is the most recognizable coastal plant for many Americans. Beyond its aesthetic qualities and dune stabilizing ability, this coastal grass is a mystery to many beachcombers.

In Georgia and Florida, it is illegal to damage or steal Sea Oats from their natural habitat. These states have recognized the value of Sea Oats as a way of naturally maintaining dunes that run along the coast. Sea Oats stop erosion and act as a barrier between the water and houses along the beach, and grow as far north as Virginia. This robust member of the grass family forms large colonies with evergreen leaves that are long and pointed. The spring flowers are subtle, but the fall display of large oat-like plumes are the show stopper. Sea Oats clusters also become a habitat for many wildlife species and several types of birds. Loggerhead Turtle nests are often in or around Sea Oats, which act as protection for the tender eggs.

It is strongly recommended that all beach-goers leave Sea Oats alone to work its magic. This amazing plant helps to preserve the beauty of America's coastal beaches for the next generations to enjoy.

Mullein or Figwort

Spring to Fall

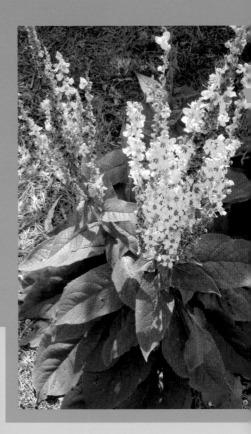

Verbascum

A relatively recent introduction to America, Mullein, often called Figwort here, has established itself across the Eastern United States. The modern gardener can find many wild and cultivated varieties of Figwort as Mullein has naturalized quite well. Oddly, the flowers are used as an herbal remedy to treat asthma and as a tobacco alternative in smoking products. Although new cultivars have given gardeners more choices in flower color, yellow is Mullein's traditional color. Considered by experts to be among the most hardy and reliable of the perennials grown today, the Figwort is set to delight gardeners for generations to come.

In Europe, Mullein has a long tradition of use among witches. While practicing magic, witches would burn dried Mullein leaves, believing that the smoke had special powers to make their charms more potent. People would hang bunches of this herb in their home in the hope that its magical powers would drive away evil spirits. Since sicknesses were thought to be brought about by nefarious spirits, Mullein was also used medicinally to help prevent illness. Herbalists near the Mediterranean Sea are known to have used the Mullein plant, crushed into a paste, to treat a variety of skin conditions. The plant has fine hairs on the leaves that, when dry, will burn quite readily; therefore, it has been used historically as a substitute for candles. This feature is attributed to the Mullein's use as a fire start.

Viburnum Obovatum
Walter's Dwarf Viburnum

Spring

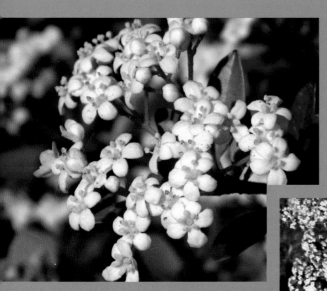

Viburnum Obovatum

A thick shrub for the coastal landscape.

The Viburnum family is quite large and has been utilized for everyday items for centuries.

Somewhat of an oddity among Viburnums, Walter's Dwarf is one of only a few compact dwarf Viburnums in cultivation. It is also rare as a strictly warm-climate shrub. Walter's Dwarf Viburnum has a planting range from central Florida to Brunswick, Georgia.

Small white flowers cover the billowy natural shape of Walter's Dwarf Viburnum in early spring, attracting bees and butterflies. Its thick branching pattern enables it to make a full barrier hedge that is perfect for Southern landscapes. Walter's Dwarf is an evergreen, but it produces some fall color on the northern end of its range.

All Viburnums, including Walter's Dwarf, have opposite leaf arrangement, where leaves emerge directly across from each other along the length of the stems. In addition to opposite, its leaves can also be alternate or whirled. Leaf arrangement type is one of the first identifying features that a beginning gardener can look for when starting to learn a new plant family.

Vigna Snail Vine held magical powers for ancient people.

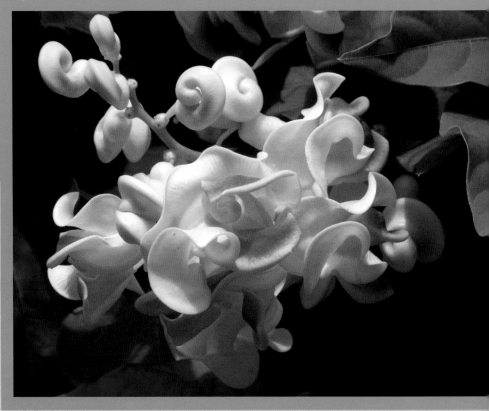

Snail Vine, a scandent tropical vine in the Fabaceae family, is a close relative of beans, Indigo, lentils, peanuts and peas. Cultivated for its bounty of multi-colored, pastel flowers throughout the southern United States, Snail Vine is native to tropical areas of South America and can be grown as a die-back perennial in Florida. Gardeners north of Florida can grow this heat- and humidity-loving vine as an annual for a summer border.

Long, twining vines grow quickly in the heat of early summer, while its leaves display a tri-foliate configuration. The vine can extend several inches a day and will need support from an arbor or trellis.

Showy, bright, and richly colored pastel flowers of Snail Vine develop in large, loose clusters in the late summer and into the fall. The flowers of the Vigna Caracalla are distinctly in the shape of a snail, hence the common name, Snail Vine. Late in

Vigna was grown in America before 1766.

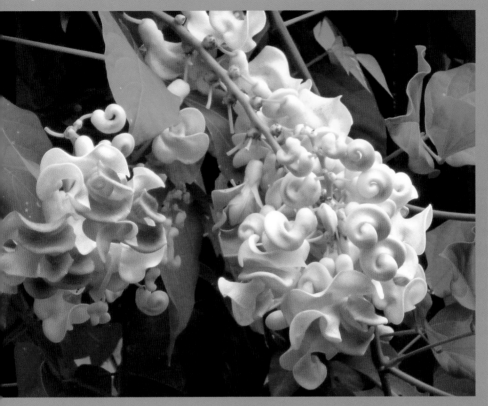

the fall, the flowers fade and a classic legume fruit is on display into the winter months; this fruit is edible.

The bean family is, and always has been, among the most economically important crops to mankind. The bean is a staple food source for many countries. The Snail Bean has been grown along the coastal regions of tropical South America for centuries and has long been associated with magic. South American native peoples once believed that the Snail Bean could be offered to the dead to entice them back to the world of the living. It was thought that the beauty of the flower was superior to anything in an afterlife, and that the dead should continue to want the beautiful things of this world.

Viola or Pansy

Viola

Spring to Summer, Annual

Viola

A classic garden flower, the Viola is edible.

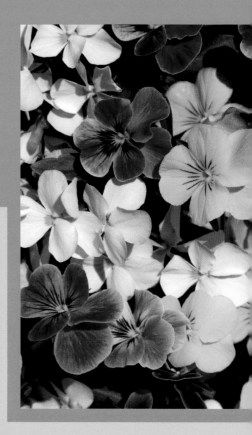

The Pansy is a classic, old-fashioned garden flower planted in European gardens since ancient times. It came to America from England on the ship *Mayflower* in 1620, and has been revered in America ever since. Coastal gardeners have hundreds of varieties and color patterns to choose from. The common name Pansy derives from the French word *Pensee*, which means "remembrance or thought," therefore, when pansies are presented, the name means that the giver is saying, "I'm thinking of you."

In the southern garden, Pansy is a fall and winter annual that will sometimes self-seed, and return the next year. In northern gardens, it is a spring and summer annual that will need to be replanted each spring. Although they look delicate, Pansies are quite hardy, withstanding all but the hottest summer sun.

Pansy is an edible plant that is often used as a dinner table garnish at formal occasions. High in both vitamins A and C, the Pansy will delight dinner guests as a salad topping or mixed-green addition.

Violas are steeped in folklore. One story comes from central Europe in the Middle Ages. There, Pansies were called Posies and they were used to disguise unpleasant odors such as the stench of death during the Black Plague. During outbreaks, villagers would gather around the corpses of plague victims with posies in their pockets, hold hands and dance around the burning bodies in an attempt to stop the disease and to deal with their grief. A gruesome, yet traditional, children's song developed from this ritual: *"Ring around the Rosie, pockets full of Posies, ashes, ashes, we all fall down!"*

In a more romantic story, it is said that someone can read a lover's intentions by counting the veins in the leaves of the Pansy. One vein means that the lover will befall an early death. Two veins in the leaf means there will not be love. Three veins mean there is hope for the love to flourish. Four veins mean there is a future with this lover and a long life together can be expected.

Chastetree or Monk's Pepper

Year Round

Vitex

Vitex, also known as the Chaste Tree.

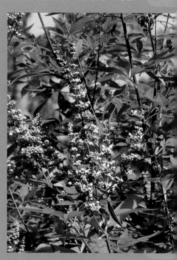

A reliable shrub in the coastal border is Vitex, which strongly resembles the Butterfly Bush, a distant relative. Unlike the Buddleias, the Vitex is native to coastal areas of the Mediterranean Sea. Vitex withstands harsh coastal climates with ease, but can be grown farther inland as well. In a coastal area, long slim branches of Vitex sway in the breeze, creating a contorted structural appearance.

This ancient shrub is steeped in folklore from its native region. A deciduous shrub, the Chastetree is bare of leaves in winter months and the downward-arching branches appear to be skeletal fingers picking up Trick or Treaters on Halloween. Therefore, Vitex is sometimes said to be haunted by spirits of the night. In Italy, its soft, lavender flowers were gathered and mixed as a potpourri to attract butterflies to the house of a woman who was being courted. Accordingly, if butterflies came to the house, love would spread its wings and envelop the couple in concupiscence.

The common name, Chastetree, comes by way of another folklore tale from Greece. In ancient Greek culture, the festival of Cerius was celebrated each year to exalt chastity, and the leaves and flowers of the Chastetree were gathered as a garland. This string of flowers was presented to a virgin to protect her from the advances of a man until her wedding night. In actuality, the berries of the Chastetree act as a hormone-suppressant in women and are sometimes prescribed as an herbal remedy for symptoms of menopause. Vitex was featured in author Roy Heizer's first book, *Savannah's Garden Plants*.

Weigela or Hummingbird Bush

Spring to Fall

Weigela Florida The Weigela is a fun and easy to grow shrub.

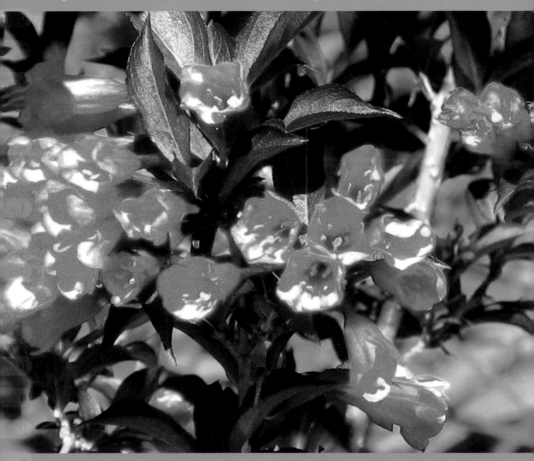

The botanical name *Florida* does not, in this case, mean the state, but the Latin word for "floral" or "flower." The Latin word is, though, where the state of Florida got its name. *Weigela Florida* therefore means, "Flower of the Weigela," and this shrub grows from Virginia through the Carolinas. Originally the Weigela was a medium-sized woodland shrub that came to England by way of China. It was appreciated for its reliable growth habit and trumpet-shaped flowers that attracted hummingbirds in droves. Gardeners began to replant Weigela in their gardens to draw hummingbirds, and a now-classic American shrub was introduced.

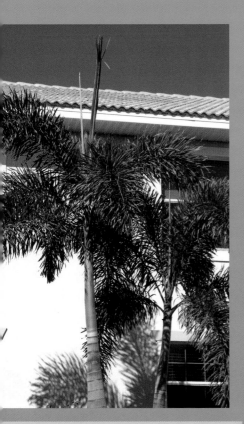

Wodyetia Bifurcata
Foxtail Palm

Evergreen

Wodyetia Bifurcate

The Foxtail Palm is quite frost sensitive and only grows in Florida.

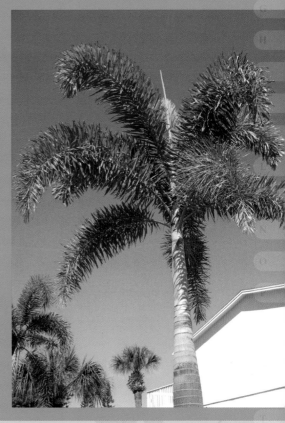

An appropriately named Palm, the Foxtail is a study in texture. While Palms are a diverse family of plants, it is the Foxtail that landscapers in central and south Florida choose as a primary ornamental specimen. The majestic beauty of the Foxtail is a landscaping complement to the slightly larger Royal Palm. The Foxtail Palm can be seen in skylines in the cities of Key West, Miami, Orlando and Jacksonville.

The first botanical name Wodyetia, is reportedly the name of the person who introduced this palm to the *International Palm Society*. The Foxtail Palm's second botanical name, Bifurcata, describes its double-split frond arrangement. "Bifurcate" means doubly split or divided into two sections or branches. The Foxtail Palm, native to Australia, has been voted the most popular palm in the world.

Zinnia

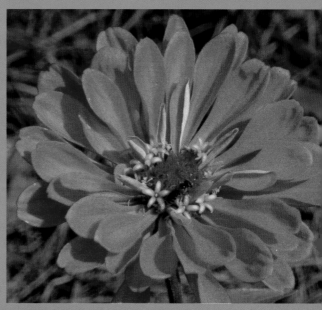

Zinnia

The Zinnia is a heat and humidity tolerant annual for gardens all over the south. The long lasting flowers are stunning in any sunny border.

A self-seeding plant in southern coastal regions and an annual in the Carolinas and Virginia, Zinnia is the most heat-tolerant flowering plant grown today. No matter what heat and humidity summer brings, Zinnia performs with spectacular results. Zinnias flower in early May and continue to show an amazing array of color until Thanksgiving, making it one of the best lasting flowers in the garden. Zinnias are adaptable to the salt spray and wind found along the coast. With little care, Zinnia can withstand harsh beach-front landscape conditions.

Zinnia is also a favorite garden flower with wildlife enthusiasts, attracting all kinds of bees, butterflies and moths. Since Zinnia is nearly disease and pest resistant, it requires no chemical spray and, therefore, creates a safe environment for beneficial insects.

INDEX OF COMMON AND BOTANICAL NAMES